How I Learned Not To Be A Photojournalist

HOW I LEARNED NOT TO BE A PHOTOJOURNALIST

Dianne Hagaman

THE UNIVERSITY PRESS OF KENTUCKY

Copyright © 1996 by The University Press of Kentucky

Scholarly publisher for the Commonwealth,
serving Bellarmine College, Berea College, Centre
College of Kentucky, Eastern Kentucky University,
The Filson Club, Georgetown College, Kentucky
Historical Society, Kentucky State University,
Morehead State University, Murray State University,
Northern Kentucky University, Transylvania University,
University of Kentucky, University of Louisville,
and Western Kentucky University.

Editorial and Sales Offices:
The University Press of Kentucky
663 South Limestone Street, Lexington, KY 40508-4008

Library of Congress Cataloging-in-Publication Data

Hagaman, Dianne, 1950-
 How I learned not to be a photojournalist / Dianne Hagaman.
 p. cm.
 Includes bibliographical references (p.) and index.
 ISBN 0-8131-1958-8 (cloth : alk. paper). —ISBN 0-8131-0870-5
 (pbk. : alk. paper)
 1. Hagaman, Dianne, 1950- . 2. Photographers—United States—
Biography. 3. News photographers—United States—Biography.
4. Photojournalism—United States. 5. Women photographers—United
States—Biography. I. Title.
TR140.H24A3 1996
770'.92—dc20 95-43906
[B]

This book is printed on acid-free recycled paper meeting
the requirements of the American National Standard
for Permanence of Paper for Printed Library Materials.

Manufactured in the United States of America

For Howie Becker

Contents

Acknowledgments

Many people helped me do the work presented in this book, and I want to thank them all: the residents and workers at Thunderbird House, especially Dave Albert and Ernie Turner; people from the missions and churches I worked in, especially Dianne Quast, Greg Alex, Fran and Lee Chase, Linda Larsen, Gracie Brooks, John Nelson, Susan Kresge, Jim Fergin, Gladys Boswell, Orvel Kester, and Bud Cripes; my former colleagues at the *Seattle Times*, especially Kathy Andrisevic and Gary Settle, and Rich Shulman of *The Herald* (in Everett, Washington); my teachers and fellow students in photography at the University of Washington, especially Vicki Demetre, Marilyn Evans, Sarah Hart, Ron Carraher, and Chris Christofides; and the friends who read and commented on the manuscript at various times: Mary Jo Neitz, John Hall, Jay Ruby, Harvey Molotch, Doug Harper, Bruce Jackson, Diane Christian, Michael Joyce, and Howie Becker.

This book began as an MFA project in photography at the University of Washington. I owe special thanks to Paul Berger, who advised me while I was doing it. An early version of this book appeared as an exhibit at the Curved Entrance Gallery at Stephens College. I owe special thanks as well to Jan Colbert, who designed that exhibit and this book.

Photojournalism

n the 1980s, I began a photographic project that started as a study of an alcoholism treatment program but eventually came to focus on religion; in particular, on the hierarchy and sexism that characterize American religious institutions. I had worked for years as a newspaper photojournalist in Seattle, where the project was done, and elsewhere. At first, the experience and knowledge I had acquired working on daily newspapers were the chief influences on what I did and the results I got. I thought that the only learning I had to do was about the subject as I then saw it: alcoholism treatment. I took what I knew about photography for granted. It was a hard-won skill I could count on. I knew what a "good" photograph was, and I knew good work when I saw it. It didn't occur to me then that a big chunk of my field work would be an exploration of how to make photographs that communicated my understanding of what I was studying more fully than those "good" ones could.

But my subject evolved, and so did the kind of photographs I made. They had to change, because, in some fundamental ways, the conventions of newspaper photojournalism hindered the expression and working-through of my ideas about what I was looking at. As I investigated religion, I began to develop ideas that were inappropriate as newspaper stories, although they were perfectly good ideas from the perspective, say, of feminist social science. My professional habits gave me no way to embody those ideas in visual images. In freeing myself from the constraints of newspaper photojournalism, I learned what those constraints had been. They were nothing as simple as an editor telling you you cannot do that. Rather, they were built into your idea of a suitable subject and of the right ways to photograph that subject, the subject and the right ways growing out of what the newspaper needed.

Just as my ideas about photography and my subject evolved during the project, so did my conception of the final form of presentation the project would take. When I started, I didn't know explicitly what that

final form would be, although I knew the project would contain far too many photographs for a conventional newspaper picture story. I thought perhaps it might be some kind of book or, more likely, an exhibit in conjunction with the Seattle Indian Alcoholism Program. There would be text, but it would be information about alcoholism and possibly oral histories of the individuals I photographed.

Any subject is intricately entwined with the form used to tell about it. The form sets the boundaries for the kinds of questions that can be posed and answered. The medium limits or expands the number of possible approaches and styles of presentation. Written text and photographic images are two ways of getting at something, and in the end I used both — certainly more text than I had ever imagined I would in a photographic book — to get at the things I wanted to talk about.

Doing this project was a process of studying religious groups; of studying photographic conventions and the way they enable (or, conversely, stand in the way of) gaining knowledge and communicating it; and of studying my own personal development as a photographer and investigator of the social world. My subject, in the end, was a braid of all of these processes. Ideas about religion, ideas about picture making, and the narrative of my own experience became impossible to separate. A little background will explain how I learned the professional skills and work habits I brought to the project. Some other things I brought to it were more personal and had to do with my ideas about religion.

I started working for newspapers in the mid-1970s, one of the first generation of college-trained newspaper photographers. Many of the photographers we replaced were men who had learned their craft in the military around the time of World War II; they called themselves "press photographers" or "news photographers." One way this new generation I was part of emphasized our difference from our predecessors was by taking a new name. We called ourselves "photojournalists." Sometime during my first week at the *Seattle Times* in 1977, Kathy Andrisevic, who had been hired there three months earlier, told me to insist that "photojournalist," rather than "photographer," be printed on my business card.

The distinction was important, and it was the word "journalist" that was critical. Journalist implied an educated "reporter with a camera," an

"Out of the darkroom and into the newsroom"

equal of the journalists who used words, the writers. It claimed that we were literate, thinking reporters who told stories in pictures and could no longer be treated like "second-class citizens in the newsroom." We meant to contrast ourselves with the oldtimers, the press photographers, who often were treated like baboons with cameras, as reporters ordered them around and told them what to photograph. Stereotypical "press photographers," as opposed to "photojournalists," were uncouth, socially insensitive eccentrics. They were often considered "characters." They made posed pictures of corporate executives giving checks to directors of charities (contemptuously called "check passings") or holding shovels at groundbreakings. They photographed spot news: accidents, fires, and crime. When a house burned, they were on the spot with their big flash and a pushy attitude. Kathy Andrisevic told an apocryphal story about how that kind of news photographer worked: A photographer from a New York paper sees an accident, rolls down the car window, and yells, "Any dead?" When someone says, "No, no one died," he rolls the window up and drives away.

Newspaper photojournalists, on the other hand, were concerned about the professionalization of news photography. "Professionalization" was code for gaining autonomy at work and the respect of fellow workers. Our battlecry was, "Out of the darkroom and into the newsroom."[1] We believed that photographers had to get control of the assigning, editing, and displaying of photographs in the newspaper if we were ever going to be anything more than second-class citizens. To do all these things, we had to spend less time in the darkroom and make ourselves a presence in the newsroom. We had to educate editors and reporters about photographs: what made a good assignment and how photographs should be used in the newspaper.

It was social mobility, pure and simple, but not for individuals. It was the collective mobility of the occupation we strove for.[2] We were demanding greater status in the newsroom as a group. We wanted to be recognized as the intellectual and creative equals of writers, not their dumb appendages. Few things exasperated Kathy Andrisevic more than hearing reporters use the phrase "my photographer," which implied that we were inferior to them. We said, "I'm not *your* photographer!" whenever reporters said that on an assignment. We discussed when and how to complain. Should we object in front of "the subject"? Or was it more professional to talk to the reporter later?

4

We had been trained to gather information, check names, and figure out what the story was, just like word people, as we called them and they called themselves. (The newspaper world was divided into word people and picture people.) We prided ourselves on being able to generate our own story ideas, write copy and captions, and design layouts — all jobs that had routinely been done by word people but were now considered an important part of a photojournalist's education. We believed that we had to be able to hold our own with the word people, on their terms, in order to gain their respect.

At that time, the job of Assistant Managing Editor of Graphics — someone who supervises photographic work and graphic art on the newspaper and is expert in visual materials — didn't exist on most newspapers. It does now. Most photographs were edited, sized, and cropped by word people who had no training in "visuals." Although they were often called "photo editors," most of them were copy editors who later made a specialty of handling the photographic assignments and editing. The highest rank a staff photographer could expect to achieve was Chief Photographer.

The editor of the feature section at the *Seattle Times,* when I worked there in the seventies, was notorious for cropping photographs into circles, pentagons and, on Valentine's Day, hearts, or insetting them in other photographs. This was anathema to us. We were purists — no goofy shapes and no insets.

The Missouri Crusade and the Struggle for Autonomy

This striving for professional status had its origins, in part, for those of us who photographed for daily newspapers, at the University of Missouri School of Journalism, which then had the best-known photojournalism program in the country. Its graduates got good jobs and were respected. The faculty at Missouri were among the chief proponents of this new, elevated view of newspaper photography. The influence of the school spread beyond the people who had studied there.

I learned about the Missouri orientation during the year Kathy Andrisevic and I shared a small darkroom at the *Seattle Times.* It later became more common for newspapers to have large, communal darkrooms that all staff photographers shared to do their printing, but in the late seventies at the *Times* photographers had their own darkrooms. There weren't enough rooms to go around, so someone — I never knew who —

decided to put the two women together. (Kathy was two years older than I, a more experienced photographer, and a graduate of a better journalism school, the University of Missouri. I got my degree at San Jose State.) We scrubbed our darkroom, removing the dried, caked fixer on the sink and the cupboards. We tossed out the old film canisters and mangled strips of negatives piled everywhere by the previous occupant. Kathy set her own Leitz enlarger (it only printed from 35mm negatives, which has a significance I'll explain later) on the newly cleaned counter. Along the wall near the Leitz, Kathy kept her copy of *Visual Impact in Print,* by Gerald D. Hurley and Angus McDougall.[3] McDougall had been Kathy's teacher at Missouri.

This book had a great influence on my generation of newspaper photojournalists. It outlined a program for changing the kinds of photographs editors assigned and the way those photographs were eventually displayed in the paper. The book addressed itself to editors and designers as much as to photographers. It outlined a new aesthetic, different from the one the oldtimers used to photograph car wrecks and ribbon cuttings. Significantly, it also outlined a program for changing the status of newspaper photographers.

The book advises that photographs be cropped to be "lean and meaningful," "trimmed to [their] essentials" so that their "content" can be "quickly grasped" by readers. It advises deleting "distracting elements" (what working photographers often refer to as "clutter"), "correcting" camera tilt, and "reducing the apparent distance between the camera and the subject." The authors commend and show examples of work in which there is "no posing" and "no camera consciousness" on the part of the subject. If a photograph is posed, then "credibility suffers," while unposed photographs have "believability." They praise photographers for making pictures with "eye catching quality" and for going "behind the scenes." They tell photographers that "the best photojournalists" are "blessed with good taste, unhandicapped by eccentric behavior or attire," and, in their dealings with subjects when on assignment, they "quietly establish rapport."

Editors are told they "must graduate from single-picture thinking," that "editor and photographer *together* must plan assignments," photographers "must have time to probe," and "pictures must be edited for variety and impact." In a chapter titled "The Editor," the authors write that "the

mating of pictures and words — the right words locking step with the right pictures — is what good photojournalism is all about. If the marriage is to work, neither should be subordinate to the other." Designers are chastised for layouts in which "pictures are used not as pictures but as decorative elements" and told that "the best picture-handlers are purists." They are commended for layouts in which "size is wisely reserved for pictures stronger in emotional impact," "words and pictures are closely integrated and always in careful balance," and "meaning [is] clear enough to be grasped at a glance."

The struggle for professional autonomy and respectability continued for at least twenty years. In 1990, John Long, president of the National Press Photographers Association, expressed the same concerns in a column in the Association's official magazine:

> We also must remember that photographers are still second-class citizens in the newsroom. The newspaper and television news operations quite simply belong to the word people, so if we are to work on their turf and gain their respect, we have to speak their language. We can be experts in our own field, but if we cannot converse with reporters and editors on their level, we look illiterate. Reporters do not have to know about photography, but we have to know about the things that are important in their world. It is not fair, but no one ever said life was fair. We have to be better just to stay even. . . .
>
> I do not want to sound like a broken record, but you have to dress according to the nature of your assignment. Shorts at funerals are an insult to the people you are photographing and to our entire profession. But this point has been made before and some people just do not want to listen. . . .
>
> It is a simple thing, but at least read your own paper or watch your own newscast.[4]

Part of the burden of being a newspaper photojournalist was the expectation that you went out and got newspapers to change their ways. Papers like the *Seattle Times* were considered difficult to change. They had larger and more rigid organizational structures than smaller papers and, in particular, a fragmentation of jobs enforced by the rules of the Newspaper Guild. Writers weren't allowed to make photographs for the paper

(unless they were on an assignment a few hundred miles away from the office); more important to us, photographers weren't allowed to write or lay out stories. On a smaller paper, where jobs weren't so narrowly defined, a photographer could write copy, design layouts, and even, at some newspapers, do pasteup. A photographer could have more control over all the steps in the process: the kinds of stories photographed, the selection, cropping, and sizing of the photographs, and their placement on the newspaper page in relation to the text and the headlines. In addition, smaller papers usually had more space available for displaying photographs, an important consideration when you're making picture stories that contain several photographs.

For these and other reasons, many of us deliberately sought out jobs on small newspapers. Our thinking was that, in order to change things, we had to start at the bottom and work up. Before Kathy Andrisevic came to work at the *Seattle Times*, she and Rich Shulman, another graduate of the University of Missouri photojournalism program, spent nearly two years at a newspaper in Coffeyville, Kansas. Rich won the award for Newspaper Picture Editor in the Pictures of the Year contest (a prestigious contest in the newspaper business) both years he was in Coffeyville. When photographers from smaller papers started winning these contests, people at the big papers began to notice what was going on.

The Switch to 35mm and Its Consequences

We modeled our work on that of photographers for such magazines as *Life* and *Look*, who had been calling themselves photojournalists for decades.[5] They often used small-format cameras that made 35mm negatives, while the old school newspaper photographers we were replacing were still using the Speed Graflex with its flash bulbs and 4x5 negatives. Unlike newspaper photographers, they did not photograph three or four assignments a day. They worked for longer periods of time on one story. Their end product was a multiple-picture story, not a single picture. Our ideal assignment at the paper, the kind we hoped for but rarely got, was one that resulted in a picture story consisting of multiple photographs spread over many pages.

The change from the 4x5 Graflex — the kind of camera you see newspaper photographers using in old movies — to the 35mm on daily newspapers happened in the late sixties and had important implications

for how newspaper photographers worked. Since 4x5 film holders held only two sheets of film, each photograph had to be acceptable. Every exposure mattered. If you missed "the shot," you might not have time to reload before what you wanted or needed was gone. So it's not surprising that photographers, if they could, controlled the situation in which they were shooting by posing people and setting things up. Not only did a Graflex film holder have to be turned around in order to use its second sheet, but the flash bulbs had to be changed for each exposure, more time-consuming work that further constrained the kind of picture that could be made.

In contrast, a 35mm camera, such as a Leica or Nikon, used roll film that gave you thirty-six exposures, one after the other. You could take more chances, since you didn't have as much invested in each frame. The camera was lighter and smaller, so you could follow people as they went about their routine activities and get photographs that were more "candid," that appeared natural and unposed, as if the photographer was not present but was a "fly on the wall."

Gary Settle, the photo coach at the *Seattle Times* in the early 1990s (a position unheard of in the 1970s), says that when many of the oldtimers were finally forced to use 35mm cameras and film, they would put their big flash on a Nikon, just as they had with the Graflex, and complain, "Whadda ya mean, this camera isn't any lighter, it weighs as much as the Graflex, and the pictures are grainy." Some of them never adapted to the different way of photographing made possible by 35mm cameras. They made the same kinds of photographs they had always made, despite the possibilities the new equipment opened up.

Gary had been a photographer at the *Chicago Daily News* in 1966 when that newspaper switched to 35mm, but he felt luckier than the other staff photographers because he had already made the switch in 1958 when he was at the *Topeka Capital-Journal,* one of the first newspapers in the country to make the change. Before Topeka, he had been using a Rollei 2 1/4 (a negative size between the 4x5 and the 35mm), but still found the switch to a 35mm camera difficult. More experienced 35mm users made better pictures with it than he did, and that seemed paradoxical to him. The larger format was considered technically superior because it produced larger negatives from which you could make prints with finer grain and detail. The 35 mm cameras were lighter and easier to

use in some ways, but to get good negatives from the smaller format you had to be a more exacting technician when the photograph was made.

I learned photography with a 35mm camera. It was the only camera I used, the only one I wanted to use. The photographs I admired in the picture magazines and believed (not always correctly, as I learned years later) to be candid scenes of real life were often made using available light rather than a flash. The subject matter that turned my generation on was what we saw as socially relevant, visual in that it produced eye-catching and emotional photographs, like the best picture stories in *Life*, made by such photographers as W. Eugene Smith.

The magazine photojournalists we admired were "concerned photographers,"[6] which implied that they had a particular kind of subject matter as well as a particular stance toward it. They "cared" about their subjects and looked for the "humanizing element," the behind-the-scenes struggle and suffering, the victims of the world. Their stories were "uplifting," revealing the toughness of human nature and the ability of people to overcome adversity, to live in spite of tragedy. Some of the work I admired, as I look back, seems sentimental and clichéd.

We thought that what photographs did best was to "capture" emotion, and we wanted to make pictures that caused a strong emotional response in viewers. Our ideal assignments, stories with good "visual potential," generated such pictures. That was why we thought it important to "personalize" a situation. We saw people as the embodiment of some general condition or problem. Personalizing the problem generated emotion. We photographed someone in a wheelchair, intending that one person to represent everybody in a wheelchair. Such pictures had impact.

Even though this was a "new" way of doing newspaper photography, it was as conventionalized as what it replaced. It was meant (as was the older system) to solve the working problems of the newspaper photographer.[7] A daily newspaper ties the making of images to the daily production process: so many pictures a day to illustrate the stories already decided on as that day's news. The main problem I had to solve in making these photographs was created by that process: how, in a very limited amount of time, to make photographs that illustrated newspaper stories and would be accepted by editors who wanted immediately understandable pictures whose impact would entice people to read the text. I learned, like every competent newspaper photojournalist, to solve

the problem by choosing from a repertoire of standard types of pictures that used a limited number of visual components and compositional devices. Making any particular picture was only a matter of adapting the standard format to the specifics of that situation and trying to get an original twist on the standard image.

Standard ways of composing a photograph (organizing its graphic elements in the frame) enhanced its impact. I learned to use a telephoto lens to isolate the subject by making the background out of focus. (The term we used was to make the subject "pop.") I learned to use a wide-angle lens to place the subject in extreme foreground, so that it appeared much larger than elements in the background. These techniques contributed to making photographs whose message was readily apparent. Standard images illustrated the equally standardized stories I was called on to photograph. When an editor asks for a sports photograph that "says losing," experienced photographers know what kinds of gestures and compositions "say" losing and where these combinations are likely to occur at a sporting event. The categories of winning and losing and the analysis (that this is the most significant theme) have already been determined. The language, the form, the ideas are already set and are applied to all situations.

Consider the hug. A picture of two people hugging is generally useful as a sign of emotion, an ideogram for sorrow or happiness, depending on the context. When you are assigned to a funeral, for example, you know that everyone back at the paper will be pleased if you make a photograph of people hugging at the side of the coffin. If you show the coffin, the picture is immediately readable as "funeral." This makes it a good "story-telling picture." The coffin, a strong visual element, sits where people will parade by it. Eventually, two of them will hug next to it. The hug — obvious visual shorthand for the emotion — is bound to happen. All you have to do is get the coffin and the hug together in the frame without any distracting background. The more successfully you do this, the greater the photograph's impact. This picture "works" for every funeral you will ever have to cover.

Photographers, then, as a matter of efficiency, shoot from an implicit script, using standard forms to say standard things about standard topics. The script is derived from professional practices and conventions that define appropriate subjects and standards of good work. Eventually,

these skills, and the physical movements required to accomplish them, became embodied knowledge, things my body knew how to do without conscious direction. Internalized, they seemed natural, intuitive, instinctive. My body knew where to stand, how to hold the camera, when to make the exposures.[8]

Religion I didn't intend to study religion when I began photographing an alcoholism treatment program for Native Americans. I went on to photograph at missions and shelters for the homeless because many of the people in the alcoholism program had lived on the streets and frequented these places before entering treatment. I knew nothing about the activities of the missions and shelters or the extensive networks connecting them to organized religion. The link between the two worlds, as I later learned, was more than an arrangement for financial support; many church members regularly went to the missions to serve meals and testify at the gospel services. These things became apparent only when I learned how the missions and shelters operated. Later still, I learned how these groups differed among themselves in how they assigned blame for and assessed the causes of the "problems" they saw in the missions and how they decided what had to be done to fix things. In large part, I became interested in religion because I couldn't avoid it. One way or another, it dominated the lives of most of the street people. I had had an uneventful and conventional Catholic religious upbringing, which didn't take. I stopped going to church when I was about seventeen. Although I didn't go to Catholic schools when I was a child, I did go to Saturday morning catechism. I had none of the unpleasant or traumatic experiences described by some of my generation (I was born in 1950) who did go to Catholic schools. Religion was not important in my adult life.

However, religion is important to the mission system. It is the source of contradictions built into every aspect of that system. If you think of religion as a great moral force, as many people do, you are immediately confronted with those contradictions. Within the mission system religion could work in a very unkind way. You could see religion's power and the way some people used it to exert control over others. One group of people — mission workers and church volunteers — supplied or denied food and shelter to another group — street people and alcoholics — who

needed it. The street people and alcoholics got what they needed only if they did things the mission people required of them, things they often didn't want to do.

As I learned how the missions worked, I began to look at religion as a method of control. Later, I looked for how religion was used as a method of control in more subtle instances, in which the power ratio wasn't so lopsided. Social power isn't hidden in the missions as it is in middle-class churches; the power of the church isn't as diluted or disguised as it is in other areas of life. In the mission world, it's not spiritual food the church provides, it's the real thing, and that makes the exercise of control more obvious. The mission workers and volunteers sometimes refer to the spiritual, metaphorically, as food for the soul. But it's not a lack of spiritual food that is bothering the people who come to the missions; it's the physical sustenance of life that's on their minds. The spiritual isn't as potent a controlling device as real food, and it's the real food the missions use that brings in the street people and persuades them to participate in the missions' spiritual activities.

At Thunderbird House, the treatment center for Native American alcoholics, I photographed the Sacred Circle. Once a week the counselors and clients who attended would pass the burning sage and the eagle feather. The ceremony was based on what they knew of an older, naturalistic Indian belief, salvaged from the time before the Christian missionaries arrived. I photographed at Thunderbird for a couple of years before doing the work in this book. Religious beliefs and practices were always around there, but on the periphery. At most of the missions they were front and center, and I noticed the difference.

What began as a photographic study of alcoholism and Native Americans became a study of religion and hierarchy. What began as an exercise in conventional photojournalism became an exploration of new ways of visually representing my understanding of social life. What follows is a description of those transformations.

How I Learned Not To Be A Photojournalist

Getting Started

I returned to Seattle from Idaho in the summer of 1981 to work at the *Seattle Post-Intelligencer.* I had moved to Idaho a few years before to work on a small newspaper in Twin Falls, but for the last year of my stay there — having left that job and surviving on my savings and the generosity of friends — I photographed at the Duck Valley Indian Reservation. I used those photographs to get the *Post-Intelligencer* job. They were the only photographs I showed Chuck Freestone, the assistant managing editor for graphics, when I interviewed. No sports action, feature, or spot news, just Duck Valley. When I was thinking about doing an independent project, it was Chuck who suggested that I photograph Native Americans in Seattle.

I wanted to work on an independent project in order to develop a deeper, longer-term story than newspaper work allowed. In the past I had often worked on stories of my own with the intention of publishing them in the newspaper I was working for. I did the work on my own time, because these pieces took more time to do than the paper was willing to pay for. But doing this let me photograph topics I chose myself and found personally interesting and important to explore. Duck Valley was the first photographic work I had done that wasn't intended from the very beginning for a newspaper.

I began by checking out Indian organizations in the city. The Seattle Indian Health Board had many programs, including a clinic at the county hospital, a substantial alcoholism program with outpatient counseling downtown, and an inpatient treatment center, Thunderbird House, south of the city. United Indians had the Daybreak Star Center in Discovery Park and the Youth Center downtown. I called Thunderbird House first and arranged a meeting with Harold Belmont, the director of the program. Alcoholism was a serious problem at Duck Valley, and I had wanted to get more than a superficial understanding of it while I was there, but I ran out of time.

I didn't actually start working on my Seattle project until the follow-

Fig. 1. Outside the Chief Seattle Club

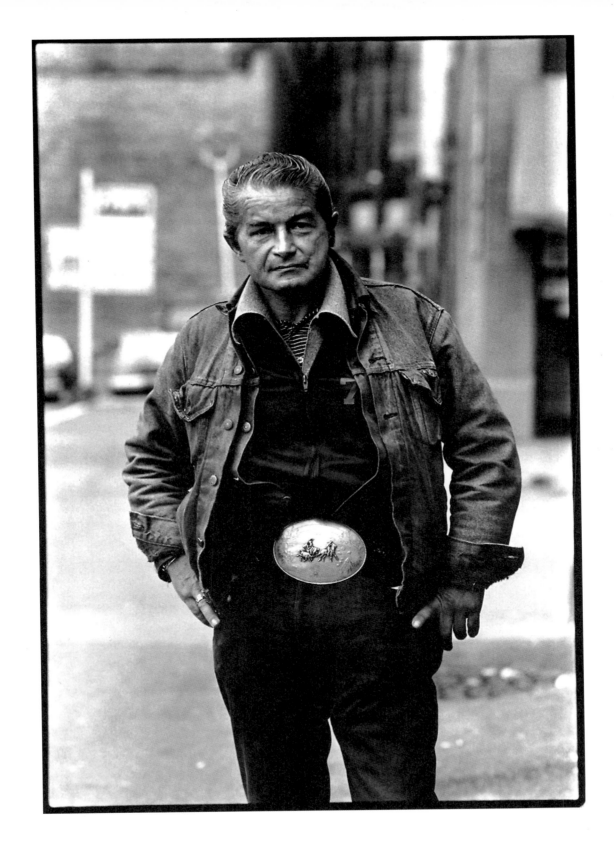

ing spring. By that time, Harold Belmont had left Thunderbird House and been replaced by Ernie Turner. So I met with Ernie Turner and showed him the Duck Valley photographs. He was enthusiastic about my photographing at Thunderbird House. Ernie was a native Alaskan who had drunk for more than twenty years, screwed up his marriage and his job, then lived on the streets. He stopped drinking about eight years before I met him and started counseling other Indian alcoholics. He was a charming man. He adopted the theories of Dr. James Milam,[9] co-author of *Under the Influence: A Guide to the Myths and Realities of Alcoholism.* I bought the book and began to read it, along with a lot of other stuff Ernie or the other counselors gave me.

At Ernie's suggestion, I talked to Dave Albert, Ernie's buddy and the director of the outpatient alcoholism program downtown. Dave and I liked each other right away. He was a Canadian Indian, and, like Ernie, he had been a drunk for more than twenty years before he got sober and started counseling. While Ernie was stylish, professional, a public speaker, and schmoozer, Dave was shy and slender and dressed like an old hippie, with an untucked-in shirt and a ponytail down to his waist. He usually wore a colorful wool hat on his head.

The first photograph I made of the alcoholism program was a portrait of Dave sitting in a classroom in the outpatient center wearing his favorite hat with the pom-pom. It's a sweet portrait. I knew when I made it that it was an important picture because Dave and I would show it to everyone at the treatment center, and they would evaluate what I was doing by that photograph. If they liked it, it would make my life much easier. They would be more accepting and accommodating, and I could do my work better. Ernie and Dave were the two main figures in the alcoholism program, and their OK was critical. What wasn't so obvious to me was that I, too, would begin to evaluate what I was doing by that photograph.

I photographed at Thunderbird House for a couple of years, all the while supporting myself with newspaper work. Then, as an extension of the Thunderbird work, I began to photograph in the Pioneer Square area of downtown Seattle, where most of the missions and shelters for the homeless were located. Many of the clients at Thunderbird House, and even some of the counselors (all of whom were recovering alcoholics), had lived on the streets of Seattle and played the mission system. After

treatment — or even before the two-month treatment was over — many of the clients ended up back on the streets. It was another part of the problem, another dimension of the work I was doing at Thunderbird House. Where did the clients come from? And what kind of life did so many go back to? I wanted to find out how they lived "on the streets."[10]

I didn't think it was smart to go to Pioneer Square and hang out with the street Indians. It wasn't safe, I didn't know the ropes, and I didn't want just to photograph someone passed out drunk on the sidewalk. What would I learn from that? So I asked Dave Albert to take me on a tour of the area, to show me his old hangouts from the time he lived on the Seattle streets, and to introduce me to Father Talbot. Dave had told me that Talbot ran a mission for the street Indians. I thought that might be a good place to start, because it would give me a place to hang around and get to know the street Indians and to photograph them — a "home."

Finding a "Home"

A home, for someone doing the kind of work I was doing, is a place where people come to expect to find you. You cease to be an outsider who needs to explain repeatedly why you're there, doing what you're doing. When new people come around, the "regulars" vouch for your character and your right to be there. That often makes strangers more willing to accept and cooperate with your photographing, talking, and interviewing. You can hang around without being intrusive, see what happens, get to know people. I learned the importance of this familiarity when I was working at Thunderbird House. Actually, I had learned the lesson earlier. In Duck Valley I was always adding links to a chain — mainly new households, and friends and relatives of people I had already photographed.

Thunderbird House clients stayed for two months, but I worked there for two years while a steady stream of new people came and went. After a few months I realized that I was more comfortable at Thunderbird, more connected to the other people already there, than were any of the new clients just entering the program. I knew the ropes, the staff, and the other clients who were further along in the program. And they knew me; they expected me to talk with them, to ask questions, and to make photographs and return with prints for them to see and keep. This created an ease that I now realize was invaluable in allaying

their suspicions and overcoming the reluctance new residents may have had.

Working on newspapers, I had learned how to walk into a strange place with people I'd never met and quickly create enough of a connection to make the photograph that the assignment form in my pocket called for. It could be delicate sometimes. A stranger wanting to make a photograph for publication in a newspaper isn't particularly welcome at a fire, an illness, a death in a family, or a lawsuit. Others are perfectly willing to be photographed, but are shy or self-conscious, awkward. This skill let me visually mimic the kind of knowledge and familiarity you have in a real home, the relaxed atmosphere in which I could make candid photographs. When I went into a strange place, it was efficient to know what kind of photograph would be ideal for the newspaper. If it's grief or shock, then a photograph of people comforting or hugging one another was required. The challenge was to keep everybody relaxed or preoccupied so I could get the photograph and leave.

But, since I "belonged" at Thunderbird House, I could take my time, watch, study, and learn something new. It felt much more comfortable to be working in a place where I'd spent time, as if I had more right to the knowledge. The ultimate justification for making newspaper photographs was the public's right to know, the public good. On general assignments the connection to a paper was sufficient justification for my presence. People knew what to expect. Actually, for the longer projects I did on my own time for the newspaper, I often had to reassure people and explain why a newspaper photographer would want to spend days or weeks photographing them. Mostly they expected me to take a picture or two and leave quickly, like the old-time news photographers who routinely posed people for the photograph and blasted a flashbulb.

Making a New Kind of Photograph

When Dave Albert and I made our tour of Pioneer Square, Father Talbot wasn't at his mission. The Chief Seattle Club was locked up. I later found the number in the phone book and called him. When I finally reached him, I told him I had been working on a project about alcoholism at Thunderbird House and asked if I could come talk to him about it.

I met him at the Chief Seattle Club in the late spring of 1985. Talbot was an irritable old Jesuit, but he took to me immediately, especially after

I made the mistake of telling him I was raised Catholic, after he asked, "Are you?". I should have mentioned that I no longer was one, because the next question he asked was, "What church do you belong to?" I didn't belong to a church, so it was soon apparent I wasn't properly in the fold. Talbot must have wondered why I wasn't and how the church could get me back. Or he may have suspected that I was a non-believer, out to criticize and to make the church look ridiculous.

The Chief Seattle Club was open from eight to nine-thirty every morning but Saturday. On Sunday there was a mass. Talbot would show up right at eight most mornings and unlock the black iron grate in front of the door. There were usually a few Indians waiting. Talbot often called the Indians heathens. Heathens were unconverted. They hadn't been baptized, and would go straight to hell (or maybe only purgatory) when they died. One day he told me that he had been at the Daybreak Star Indian Center the night before to accept an award for his mission work. He said it was very nice of them to do that but, "They're all heathens, you know."

My plan to establish a home in Pioneer Square worked as I had hoped. I got to know all the regulars at the Chief Seattle Club and, eventually, to photograph them. I worked there through the summer making portraits and talking to people about how they lived. I heard a lot about other missions — the Bread of Life (some called it the Dread of Life), the Union Gospel Mission, the Lutheran Compass Center, St. Martin de Porres, and the Matt Talbot Day Center. (Matt Talbot, no relation to Father Talbot, was an Irishman who had lived a debauched life, then stopped drinking and tried to get everyone else to stop before he died.) I met some people from the Pioneer Square Medical Clinic, the Harborview Hospital Detox Center, and the cheap hotels, because Talbot sometimes asked me to take an Indian to one of these places to "get them straightened out."

Talbot used to read to me from a book called *Ponder Slowly*. (To myself, I called it *Ponderously Slow*.) He kept trying to get me to go on a spiritual retreat. I think he thought I was good nun potential: I was thirty-five years old and single. It was an odd, surreal experience inside this crummy, dark building early in the morning, the Indians drinking coffee, eating cookies or white bread or doughnuts, and watching religious programs on the TV in the front of the room. Sometimes Talbot

would get annoyed because the television was interfering with his reading *Ponderously Slow* aloud, so he would turn it off and the Indians would have to listen to him. Once, when he did this, one of the Indians got angry, called Talbot an "old crank," and stormed out. Looking back, it seems that *Ponderously Slow* was important because it gave me the direct experience of going to a mission to be "preached at." It was probably one of the things that shifted my attention from the drunkenness to the missionness.

You can see the shift in the photographs. I made dozens of portraits during the months I worked at the Chief Seattle Club. Most of them were in the style of the work I did at Thunderbird, a style I often used in my newspaper work: direct, frontal, the subject centered in the frame, half to three-quarters body, standing out distinctly from a slightly out-of-focus background that didn't necessarily contribute much to understanding the life of the person. I tried to make the portraits compelling, but at the same time I wanted to communicate my growing understanding of who these people were and how they lived. I started making some of the portraits tighter than I usually did, framing the person more closely, as if the sharp, up-close look at the face and the eyes would reveal some essence of the person. I also started doing just the opposite, framing the portrait more loosely than I normally would have, including the person's feet and enough of the surroundings to give a sense of an urban location. But I still made the background slightly out of focus so that the person "popped" (the effect of selective focus) and remained distinctly separated (figs. 1-5).

I kept going back and forth about these portraits, sometimes thinking the close-up was better, sometimes that, no, the photograph that showed the street and the person was better. It was many months before I began to understand that, if there was any essence, it was better discovered when I stepped back even farther and attempted to make photographs about the relationships these people had to each other, the street, the mission system, and the people from the community churches who came to the missions to witness, preach, serve food, and donate clothing and bedding. Eventually, I realized that I learned more about the street people when I explored these relationships.

I never made any photographs I liked that showed the inside of the Chief Seattle Club. I remember always being concerned about the clutter in the background of the pictures and wanting to get some kind of mas-

terpiece image that would tell everything I was learning about this place. The image I wanted would be more than an "overall," as such pictures were called in the newspaper business. Newspaper overalls were routinely made on assignments where more than one photograph was likely to be published, but they were usually perfunctory, meant to provide an ambiance. This type of photograph was also called a "scenesetter," a term that more specifically indicated its function. I wanted, instead, to make the photograph my newspaper loved to publish; it would be more dramatic, have more emotion. The results I got never pleased me. The only photographs that pleased me then were the portraits I made of the street Indians, although I knew that they were no longer enough for me.

I remember the two times I tried to make wider views of the inside of the Chief Seattle Club. One was in the early morning with the guys drinking coffee. I framed the photograph to include the small plaques of the Stations of the Cross, but I was disappointed because, when you looked at the prints, you couldn't tell what they were. I went back and forth about this photograph for months. I knew (or, rather, thought I knew) that it had some valuable information in it. But at the time it was very unsatisfying. There was nothing really "happening" in it, at least not in the newspaper sense. It didn't seem to be any particularly special moment. The photograph had neither impact nor the engaging qualities of the portraits I was making.

The second wide photograph was of the football game. I had photographed the breakfast that followed the Sunday mass. After breakfast, the Indians were sitting around watching football on the TV set in the front of the room. It finally occurred to me that I should photograph this. I made one quick exposure and was about to reposition myself to organize things better, play with how things looked in the frame, when Talbot walked up, turned the television off, and told everyone it was time to leave. It was disappointing, because I didn't have a chance to make the composition acceptable to myself.

I was afraid to give up the sure winners I knew I could get with my usual methods, pictures that showed a special, singular instant up-close and so had dramatic impact. If *this* is only going to happen once, can I risk experimenting with my framing and maybe miss the chance to photograph a special moment — like Talbot turning off the TV — that was now lost forever? Or would I be too far away, so that my photograph would lack impact?

Figs. 2-5. Outside the Chief Seattle Club

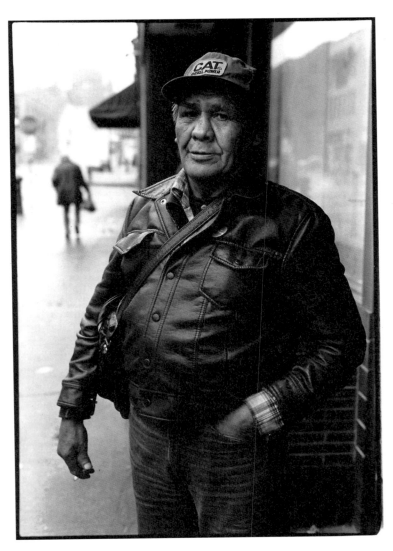

I wasn't yet thinking, as I would later on, of analyzing ongoing relationships photographically by looking for things that happened again and again rather than just once. I still wanted that unique image that captured an essence, although I didn't know enough yet to understand what that essence might be. Any essence I captured at this point would be a stereotype (about street people, poor people) that I brought to the project. Furthermore, the idea of "capturing an essence" assumes that an essence is available visually. To capture it implies that the photograph already exists objectively. It's not constructed but is literally out there for the taking.

While I was making the portraits, I also made a photograph of the TV set with the picture of Pope John Paul II propped up next to it. I photographed this three or four different times, trying to get the perfect composition and resolution. It was important to me that you be able to read the name of the pope on the picture frame and know it was the image of the current pope that was displayed for the Indians. I didn't want to push the film[11] because I would lose resolution and the pope's name would be unreadable. So I placed the camera on a tripod.

In a few frames, I had stepped back slightly in order to include the window in the mission door alongside the pope and the TV. In one of these, an Indian peers through the window (fig. 6). It was the first photograph I made that said something about the relationship between the street people and religion: The Indian is on the outside looking in. I liked this photograph, but you couldn't read the pope's name. The one with just the TV and the pope was more tightly framed, and you could read the name, but it didn't make the connection I now saw as important. In the early stages of the project, I thought that this photograph with the Indian made that connection very well, but later I decided that it was too heavy-handed. Nevertheless, it was an important picture because it led me to see the connection between the missions and the people who used them. It was a photograph whose structure reflected social relationships, its three horizontal compartments relating three social units: society embodied in the man on the television screen, the street people in the Indian, and organized religion in the image of the pope.

Soon after, I made a photograph of a homeless man sleeping on a bench in the lobby of the Union Gospel Mission. Above him, a display of mission literature surrounds a picture of Jesus (fig. 7). This was another

Fig. 6. Chief Seattle Club

photograph that articulated a hierarchical connection between the street people and religion for me: the vertical structure puts Jesus above the sleeping man.

Stepping Back I was learning a lot about how people lived on the streets from my conversations with the Indians at the Chief Seattle Club. They told me that you didn't go to just one mission, you went to them all. But, you could only go at certain times, and you had to do this or that to get a bed, or food, or clothes, and at this other one you could get a shower, etc. So I began to visit other missions to find out what they were like.

I called the Union Gospel Mission director, Guy Sire, and made an appointment to talk to him about the work I was doing. He gave me a tour of their facility and a subscription to *The Little Paper*, their in-house newsletter. I was told I could photograph the evening service if it was okay with the people preaching that night, who were from a Nazarene church in Kent, a town about thirty miles south of Seattle.

I soon discovered that there was a strong link between the missions and the community churches that helped support them. As in most of the Seattle missions, prayer services at the Union Gospel Mission were conducted by people from churches in the Seattle area. A different church group preached each morning and/or night of the month, and then the rotation started again the next month. None of the preachers ever said no to me. The leader of the group doing the service would announce that I was going to photograph, but only those people in chairs on the right side of the room, so, if anybody minded, would they please move to the left side. Once or twice someone did move, but mostly nobody cared. Also, by this time people were beginning to recognize me, especially the Indians, many of whom were still carrying around portraits I had made of them earlier.

These were the first religious services I photographed at a mission. I could photograph anything I wanted to on the right side of the room or at the altar. Although I knew I was in this wonderful situation, I was still making photographs of individuals and not the situation. During the first few services I positioned myself in front and photographed people sitting in chairs listening to the service. I used a slight telephoto lens (105mm) and essentially made portraits, sometimes with two or three people as the

Fig. 7. Lobby, Union Gospel Mission

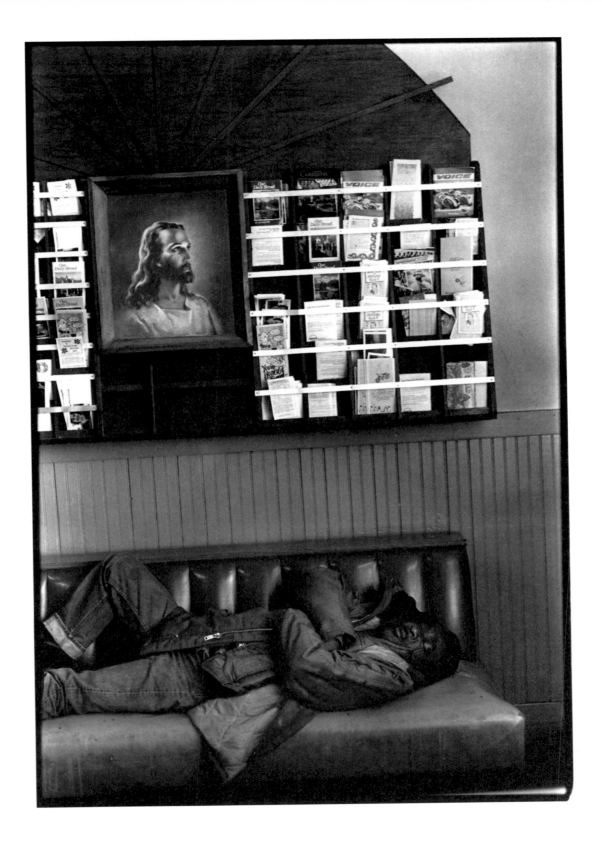

center of interest, with shallow depth of field and tight composition (usually just the subject). At times I could see out-of-focus figures sitting in rows behind my subject (fig. 8). I also made the standard cliché newspaper image of people hugging, a sure way to symbolize a subject's humanity. The photograph, made after the prayer service, shows two Indians hugging in the food line (fig. 9).

These people had to sit through an hour-long service before they were fed. The dining room was next to the chapel. After the service they lined up and filed into the dining room to eat. It was January, during a very bad winter (by Seattle standards), and they came in with snow on their boots. By the middle of the service there was a puddle of water under each chair. They were tired, withdrawn, and bored but still had to sit there before eating. So I photographed their reaction to the service. They were cold and hungry, but you couldn't see the hunger in the picture. I never adequately got across the idea of empty stomachs visually.

Eventually I made a photograph of the service that worked, one I could use as a model, one that could be studied for clues on how to proceed with the photographing (fig. 10). The photograph included the street people on the right side of the room and the religious murals on the wall above them. I had stepped back and gotten more into the frame. Stepping back was very difficult to do: my body had learned to do just the opposite. All my training as a photographer had been to step forward, to get closer, to frame tighter, to have one center of interest with no background distractions. Stepping back went against the grain of war photojournalist Robert Capa's famous dictum "If your pictures aren't good enough, then you aren't close enough." (If you're forced to step back on a newspaper assignment, you just switch to a longer focal length lens, often referred to as a close-up lens because it gives that effect.)

There was another reason stepping back was difficult: photographs like this one weren't as compelling to me as the close-up photographs. I was developing some pretty strong feelings about what went on in the missions, and I wanted the photographs to be powerful. But my notion of powerful, still tied to newspaper practice, referred to photographs that had an immediate emotional impact, were attention-grabbing and quickly understood.

Although photographs such as figures 8 and 9 have the advantages

Fig. 8. Evening service, Union Gospel Mission

Fig. 9. Evening service, Union Gospel Mission

Fig. 10. Evening service, Union Gospel Mission

of tight framing and a strong center of interest, I was beginning to understand a lot more about the missions than they let me say. The photograph of the service and murals was quiet. It didn't have that immediate punch. But its elements established a relationship between street people and religion through the parable of the lost sheep: in the minds of the church people the street people are the lost sheep. Tilting the frame up to include the murals distributed the important elements around the edges of the frame, so there is no one center of interest, no person or thing that could be said to be the subject. The subject is the relationship between all the elements.

Getting Rid of the "Holy Aura"

I went to the Matt Talbot Day Center for a meeting with its director, Greg Alex, and the week after that I met with Jim Fergin, director of the Lutheran Compass Center. The Compass Center had a female chaplain, Dianne Quast, and that interested me. They also had facilities for homeless women (as most of the missions did not) and didn't make people sit through a service for food or a bed (as most of the missions did).

I probably chose to visit the Matt Talbot Day Center thinking that, since it was funded by Catholic Community Services, the time I'd spent with Father Talbot would give me credibility there. But I found out soon enough that the portraits I had made over the summer at the Chief Seattle Club, plus the photographs from Thunderbird House, were all I needed to be taken seriously. The Thunderbird House material especially showed that I had spent a lot of time there, that I knew these people and they knew me, and that I had learned something about alcoholism. Though I told the mission people I was continuing that work, I was beginning to realize that alcoholism, for me, had taken a back seat to religion and the mission system and how the two structured the street people's lives.

I was making formal changes in the structure of the photographs, including more information in the frame and consistently using a greater depth of field in order to have more space from foreground to background in focus. But the changes were tentative, and I went back and forth about these compositional choices for months. (I made figures 9 and 10, which reflect these differences, the same evening.) Maybe I knew my primary interest wasn't the alcoholism but wasn't able to say what it was. Why was I here in these missions? My ideas about what I was doing and

the formal aspects of the photographs changed at the same time. Initially, the ideas forced the formal changes, but later the formal changes fueled my ideas by opening up new possibilities of expression.

Around this time — partly on a whim and partly out of frustration with the photographs I was making for the project — I entered the Master of Fine Arts program at the University of Washington in Seattle. Thinking back, I see how important it was to have added this peer group to my social world and critical audience. The students and faculty I knew at the university lived in a professional world of art, not the professional world of journalism I was coming from. A good part of my daily life was now spent with them in the graduate program studios or the coffee shop in the basement of the art building. Their critical concerns and criteria for photographic excellence were different from those of professional journalism. They responded to my work in ways that helped me develop a new perspective. Continuing contact with them gave me the social support I needed to develop a new way of thinking and working.

Their support was important because I didn't know at first whether the photographs I was making in this new way were good or not. I thought they were but knew they weren't like other "good" photographs I'd made, and this produced a gnawing indecision about what to do. I felt unable to express my ideas visually. The way of working I was comfortable with was constraining my ability to make photographs that expressed what I knew. It was a long time before I was at home with the new technique, before I internalized this new way of working and it became embodied knowledge in the same way the old technique had been.

My meeting with Greg Alex at the Matt Talbot Day Center went very well. I showed him photographs and explained what I thought I was doing. He was a devout Catholic, kind, and concerned about social issues the way progressive Catholics are; he was a fan of Raymond Hunthausen (the liberal Catholic archbishop of the Seattle diocese). He was also on a number of committees at Saint James Parish (Hunthausen's church). And, like Hunthausen, he was big on interfaith cooperation to provide social services to the poor and to protest abortion, the death penalty, nuclear weapons, and other such issues. Over the years I often saw him in places like the Lutheran Compass Center's Easter Sunrise Service in Pioneer Square. He had the same sort of orientation as Dianne Quast, at

the Lutheran Compass Center: it's not enough to save souls, you've got to work to make the system better.

This wasn't the most common orientation. Saving souls was the primary concern at most of the missions: if the street people would just accept the Lord, then their lives would change entirely. They would become model citizens. Underneath this is the idea that the responsibility for the "problem" lies with the individual. Efforts to help were devoted to charity and individual redemption, not to transforming the social structure that, from the point of view of Dianne Quast and Greg Alex, might be responsible for the "problem." The street people called the mandatory sermons designed to change them "ear banging." One man told me he liked to think of the sermons as "dinner theater." The mission and church people, however, saw the sermon as an important instrument of spiritual transformation and spiritual transformation as a solution to social problems.

The meeting with Jim Fergin at the Lutheran Compass Center also went very well. He wanted me to meet with the rest of the staff, especially Dianne Quast, who wasn't in the office that day. So I came back a few days later and showed my photographs to Dianne and Gracie Brooks. (Gracie managed the women's program on the fifth floor that had sixteen beds for battered and abused women and let them stay for months while they received job training and counseling.) They seemed to like my work and said it was okay with them if I wanted to photograph and hang around.

I began to visit the Matt Talbot Day Center and the Lutheran Compass Center regularly. I thought the Matt Talbot Day Center was a tough place and I never felt as comfortable there as I came to feel in some of the other missions. There were a lot of younger men high on drugs who seemed more unpredictable and violent than the people at the Chief Seattle Club.

I made a photograph at the Matt Talbot Day Center that became another model for later work (fig. 11). The photograph is of Archbishop Hunthausen and three priests from the diocese blessing the tabernacle at the dedication of the newly renovated center. The tabernacle is where the wafers that symbolize the body of Christ are kept, and it meant a great deal to Greg Alex that his center had one. Near the left edge of the frame a homeless man is sitting at a table. The priests surround the doorway to

38

Fig. 11. Matt Talbot Day Center

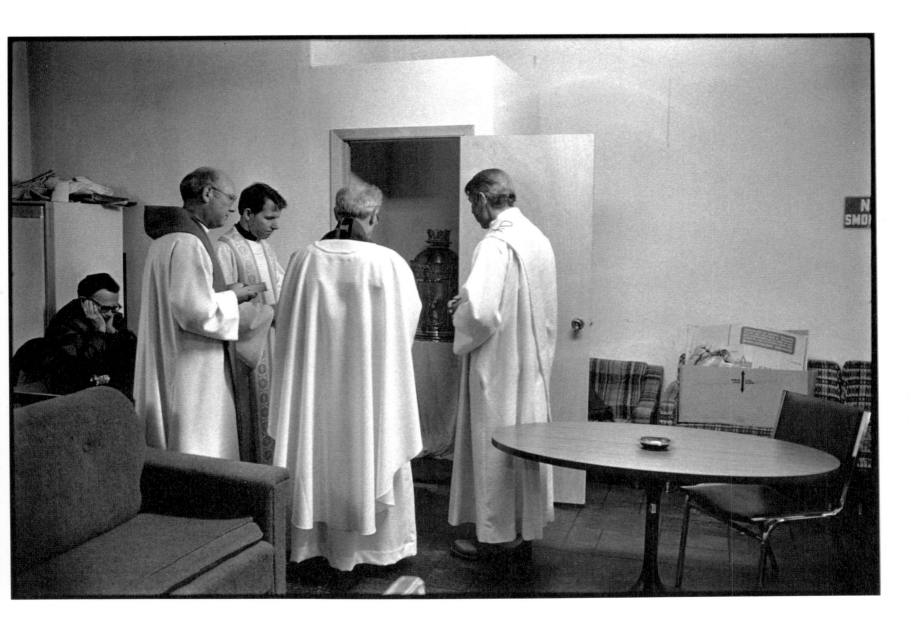

the closet containing the tabernacle. Their backs are turned to the man, cutting him off from contact with the holy object.

Who was this performance for? Certainly not for the street people. The priests were a physical barrier that kept them from the sacred space. This became important symbolically: the photograph helped me to understand how to create visual symbols, how a visible trace might be made to suggest an intangible idea or phenomenon. In this case, the barrier of priests' backs expressed exclusion as a way of exercising power. Taking it further, this exclusion expressed the priests' power to mediate between God and man, to interpret the meaning of the Holy Word for others — in this case the street people — and ultimately to define what a person's values, behavior, and goals should be.

Particularly important was how this photograph functioned as a model for analyzing religion visually. It had a certain emotional distance. I was dealing with a loaded, emotionally charged topic — religion — and I didn't want the photographs to be loaded, at least not in the conventional way, with the holy aura of spirituality. This was the first photograph I made that took the holy aura out of religion, although, at this time, I didn't completely understand how it did that. I was thinking of religion as power — social and political. It took a long time for me to change the way I made photographs, to dissociate the ritual and power from the sacred, and to make religion mundane visually so that it could be examined as a form of control and structure in the lives of the street people, just as you would examine power relationships in any other area of social life.

Earlier, I had made a photograph with a "holy light" from above, one of Pastor Henderson from Burien praying at the Union Gospel Mission (fig. 12). It's tightly framed and has shallow depth of field. The fluorescent light above him shines down on his upturned face. The light fixture itself is not visible in the picture, so the light seems to be coming from Heaven. This kind of light is a holy aura trigger or button, a visual metaphor for the mystery and presence of God the Father. I began putting light fixtures in the frame exactly because I didn't want this effect. The presence of the fixtures allowed no mistake as to where the light of God was coming from.

One reason figure 11 looked different from other photographs I had made early in this project is that I had backed up, stepped away several

Fig. 12. Evening service, Union Gospel Mission

feet from what I was photographing in order to include things I would earlier have left out. This happened on other occasions as well. At the Matt Talbot Day Center Greg Alex had specifically asked me to photograph the blessing of the tabernacle for him. I didn't position myself to make the photograph with any particular significance or quality or appropriate mood, but as a record for Greg. I had only a vague idea of what the priests were going to do and where they were going to walk, so I felt the only choice was to use a 35mm lens and frame loosely and thus got more in the frame than I would have normally. Who needs an empty table and chairs? In this more loosely-framed photograph the markings on the box above the table can take on the look of a cross, perhaps because the activity is religious, but especially when the image is placed in an arrangement with other photographs that call attention to crosses.

Realizing that my subject was the relationship between the street people and the missions was important. But making photographs that successfully described that relationship was the real breakthrough for me. I had learned that, to do that, I needed to back up and include more in the frame. I also learned that this looser framing helped create an emotional distance from the scene, so that the photograph was more likely to be perceived as a straight-forward description of what went on. These photographs could function as models for future work.

This style of photographing — avoiding exaggerated perspective, dramatic close-ups, unusual angles, or other noticeable distortion — gave the impression of neutral observation. It appeared as if I wasn't pointing to any one thing through composition or such other photographic devices as the holy aura trigger but was merely describing the whole scene as you would have seen it had you been there, a kind of deadpan look with no obvious point of view. But, of course, there was a point of view, and I began to use this style deliberately because it helped me take the sacred out of religion. I was in the early stage of developing a circular way of working in which I studied the photographs I had already made, especially the most recent ones, for clues about what to photograph next and how to photograph it. During all those months at the Chief Seattle Club, I was still looking for the kinds of photographs that conformed to what I had learned was a good newspaper image. But now I gave myself permission to photograph anything that seemed interesting, despite the clutter or the light, just to see what it looked like as a photograph.

The photograph of the blessing of the tabernacle helped me articulate what I found so unsettling about the mission system. Looking back, there seem to have been two things going on in a kind of dialogue in my mind. What is the nature of the connection between the street people and the mission system? And how do you represent these ideas, make a visual connection between the street people and the power of the missions over their lives? It's complicated. Some of the photos I had made earlier (e.g., of the pope and the television set in the Chief Seattle Club and of the man sleeping in the lobby of the Union Gospel Mission) now seemed heavy-handed. They hit the viewer over the head with a visual connection but they don't unravel the complicated nature of the relationship. They functioned mainly as milestones for me in the evolution of the project, visually stating that a connection existed: This *is*. Now, what is it? I had to investigate my emerging ideas about the connection of the mission system, religion, and power and make visual sense of the relationships.

Organizing Information Visually

The world is a clutter. It's disorganized, and every way of describing it requires conceptualization. Composing a picture, organizing elements in the frame, is a conceptual activity, a making sense of things, just as much as putting the world into words is. The consequences are significant: changing how you photograph something makes you change how you think about it, how you categorize it. I began experimenting with different ways to organize space within the frame, ways to divide and decentralize it (figs. 13-16). Putting people and objects along the edges of the frame rather than in the center when I photographed the services, for instance, let me include the crowd, as well as the ceiling and the fluorescent lights. The harshness and ordinariness of the lights became a motif with which I could link one photograph to another. I let the frame cut off parts of figures as a way to exaggerate a sense of the world extending beyond the frame and to speak of the connections this situation had with others, rather than its isolation.

I began to include doorways or windows that opened up to another, deeper space. This device allowed one scene to be organized within a larger scene and helped set up comparisons and analogies in the photograph. I saw how this worked in previous photographs (e.g., how the doorway emphasized, or framed, the tabernacle in figure 11 and how the

door window framed the man peering into the Chief Seattle Club in figure 6) and began using it deliberately.

Figure 14 is a photograph made during a morning prayer service at the Bread of Life Mission. I could see both the mission chapel and the mission office from where I stood in the hallway. The people I could see through one doorway could not see those visible through the other. The street people are watching the front of the chapel, a homeless man in the doorway is watching them, and the photographer/viewer sees them all, as well as the man laughing in the office. The simultaneous scenes in different spaces are put forward for comparison and connection in the overall frame of the image, each like a separate photograph in its own frame.

To get the deep focus, to have all the elements from foreground to background clearly visible, I had to use a small aperture, which required exposure times too long for me to hold the camera steady.[12] So I began to use a tripod routinely when I photographed the mission services. The photographs I made with the tripod appeared less spontaneous to me; they gave the effect of studied observation. At first, I worried that they were too static, so I experimented with tilting the frame, although journalistic practice forbade that. "Too static" was a phrase newspaper photographers and editors used to criticize photographs with insufficient "impact." But working with a tripod let me observe without the camera in my face all the time and let me interact with people even while I was making a photograph. Often the exposure would be a full second or longer. So what I was photographing was usually not the culmination or peak of some action or event. This took some of the urgency out of the actual photographing of a situation. For example, I didn't have to readjust my focus constantly because I wasn't handheld, wide open, and in so tight on people that every time someone moved an inch backward or forward I needed to rack the lens up or back. I was more widely framed, with good depth of field, so I was better able to stay aware of an entire scene rather than just some narrow part of it. Often, after the initial framing, I was completely free of the viewfinder. This was very different from my newspaper experience. I had a different relationship to an unfolding situation.

I began to approach photographing with the conscious intent of describing events matter-of-factly, paying attention to the interaction of mission workers and street people. To do that, I had to let go of the

Fig. 13. Morning service, Bread of Life Mission

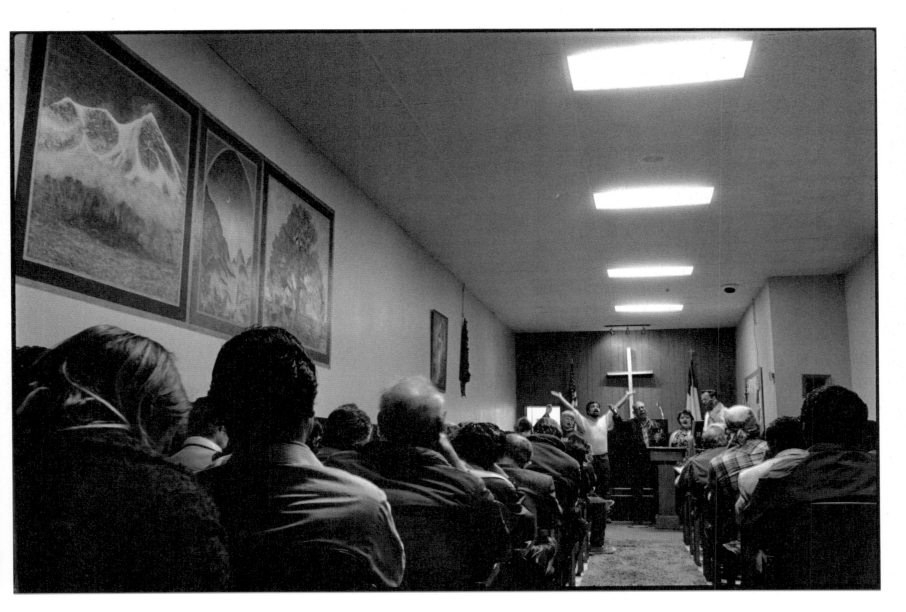

Fig. 14. Morning service, Bread of Life Mission

Fig. 15. Evening service, Union Gospel Mission

Fig. 16. Evening service, Bread of Life Mission

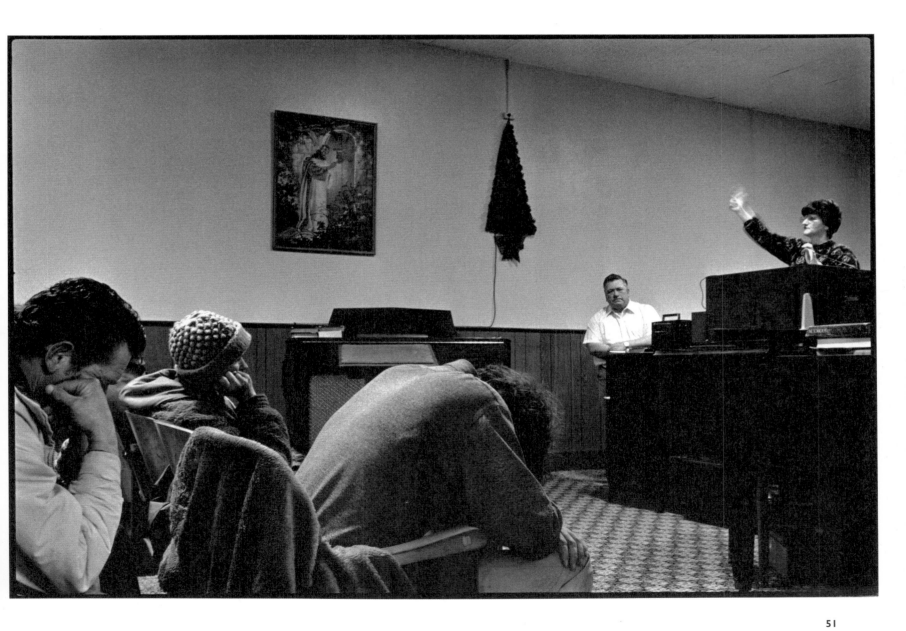

conventional newspaper definition of impact. People at the newspapers I worked for believed that readers were more likely to read a story that is illustrated with a photograph and that most readers wouldn't read more than twenty inches of copy. So a photograph that grabbed readers' attention and enticed them to read the written story was highly valued. The photograph, in their view, was supposed to call attention to a story rather than be closely studied or provoke reflection. Creating a matter-of-fact description, rather than looking for an eye-catching "moment" that summed up the story, became important to me because it implied a photograph that needed study, one whose meaning wasn't immediately apparent or understood, a photograph that wasn't a "quick read." The response I wanted from a viewer now was a kind of thoughtfulness about the subject, and that required a different way of making photographs as well as a different set of expectations from a viewer.

I practiced on empty rooms. Removing the people put the emphasis on the objects in them and on the spaces people live in. It became an interesting puzzle to go into a room when no one was there, with the intention of making a photograph that described that room, its function, and the people who might use it. I would go to the missions with my tripod and just photograph the rooms, thinking about how to organize each room, each space, in the frame and how to structure the photograph to keep a sense of neutral description so that any irony or strangeness seemed inadvertent or a natural part of the scene. I realize now that this was important practice for working out new ways of composing photographs and what were, for me, new ways of thinking about how photographs can function and look, what they can be about.

Figure 17 is a photograph of the dining room at the Bread of Life Mission. The door next to the mural opens to a passageway that connects the chapel with the dining room and kitchen. The kitchen is through the door on the far right. After the service, people lined up at the front of the chapel, walked through the passageway to one door, and then entered the kitchen through the other. In the kitchen, each person filled a plate with food and passed through another door (not in the photograph, but beyond the right edge of the frame) into the dining room. The mural was dominant in my mind, but I composed the photograph to lessen its emphasis, not putting it in the extreme foreground, but rather attempting to embed it in its surroundings.

Fig. 17. Dining room, Bread of Life Mission

Photographing empty rooms was very helpful when I was working in a mission for the first time. I could work slowly, stopping to talk to people or answer their questions. I could let them look through the camera as it sat on the tripod so they could see what I was doing. They could tell me what they thought and if there was anything else I should photograph. There was no unfolding action that needed my concentration if I was to capture it at its peak. In my newspaper work, it was always necessary to make "people pictures," preferably of people engaged in some recognizable activity or making gestures that had obvious meaning. Newspapers just don't run photographs of an empty room unless the story's about real estate. On the other hand, photographing empty rooms and cultural artifacts is standard practice in anthropological investigations.[13]

Making Each Photograph Part of a Larger Whole

I continued making portraits of individuals, but now I photographed them in the context of the mission system and looked for details that visually related the portraits to other photographs in the project. When it was possible, I included the religious paraphernalia in photographs of the common areas or people's personal shrines when I photographed them in their rooms. As I experimented with various ways of combining the photographs, I kept in mind the symbols and details I had been using. They were a way to make connections between photographs, as well as within individual photographs, and to develop gradually a symbolic vocabulary for the project as a whole (figs. 18-23).

Photographs of people raising or carrying a cross became a way for me to symbolize evangelism. Each year people from the Lutheran Compass Center led a two-block march from Occidental Park to the Seattle waterfront for an Easter sunrise prayer service. I photographed the procession because it was rare for street people and community churchgoers to participate in activities together outside the mission. After the celebration the Lutheran Compass Center served everyone a free breakfast in the mission dining room. But you didn't have to join the procession to get fed, and many of the street people showed up just for breakfast (fig. 24).

It was a cold, sunny morning and the downtown streets were empty except for the Easter procession. I walked ahead in order to photograph

Fig. 18. Newlyweds, Bread of Life Mission

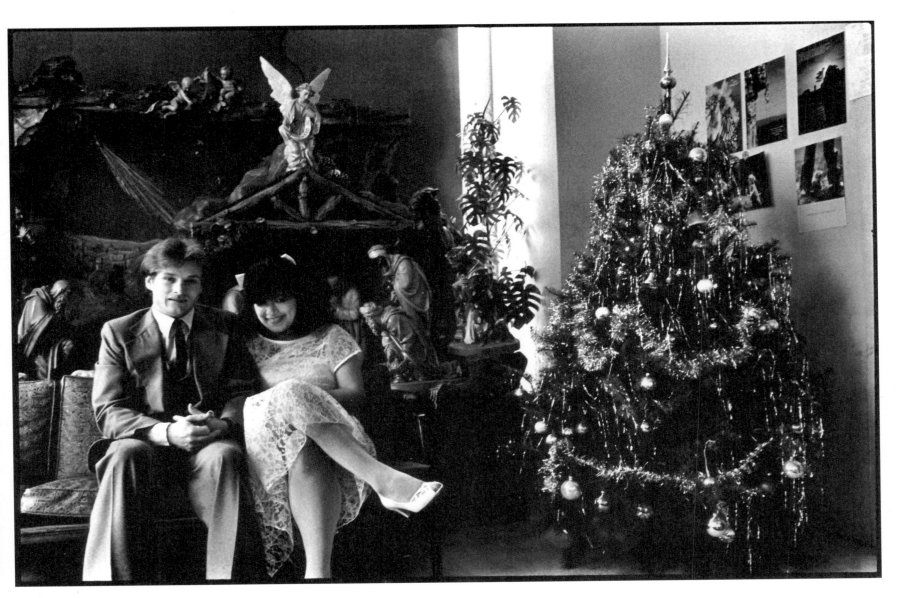

Fig. 19. Mission worker, Bread of Life Mission

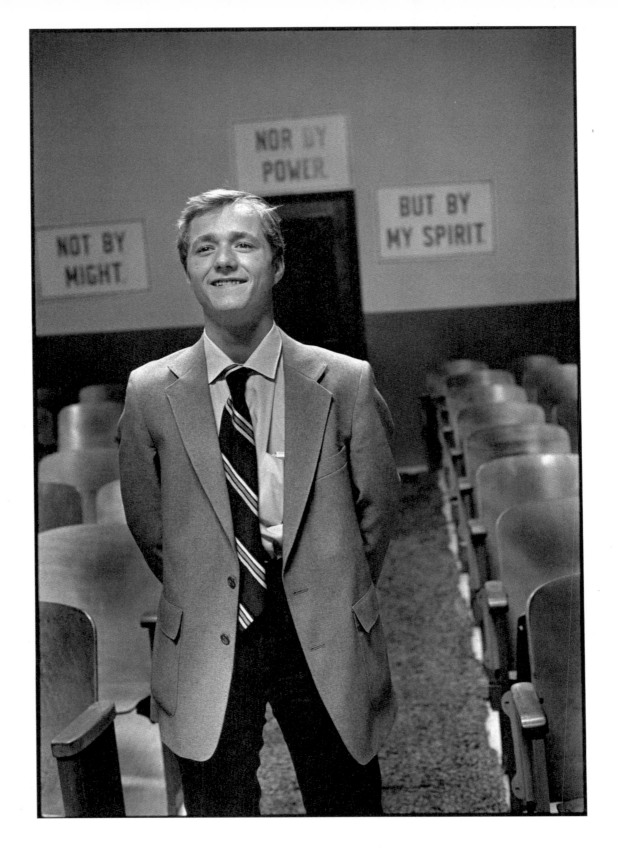

Fig. 20. Resident, Women's Shelter, Lutheran Compass Center

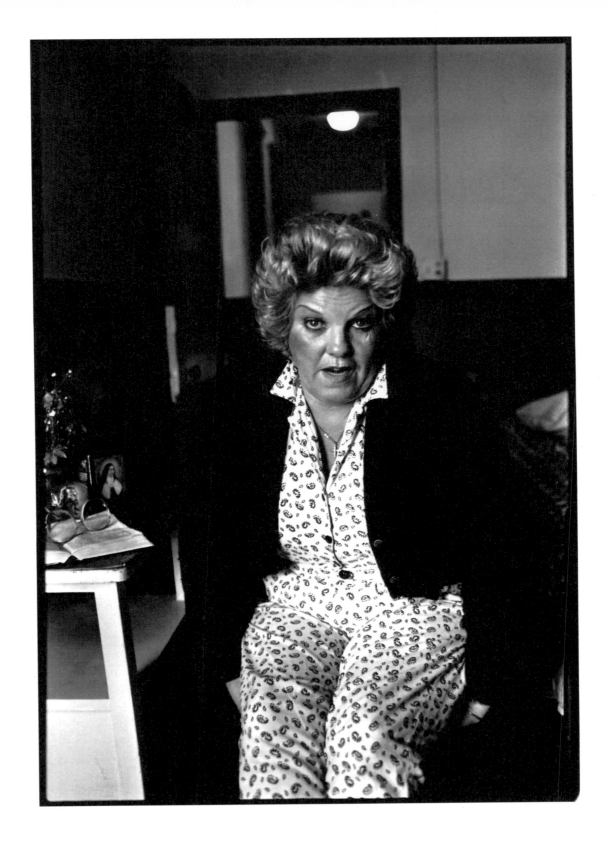

Fig. 21. Salvation Army officers with their grandchildren, Easter Sunday, Harbor Light Center

Fig. 22. Evening meal, Peniel Mission

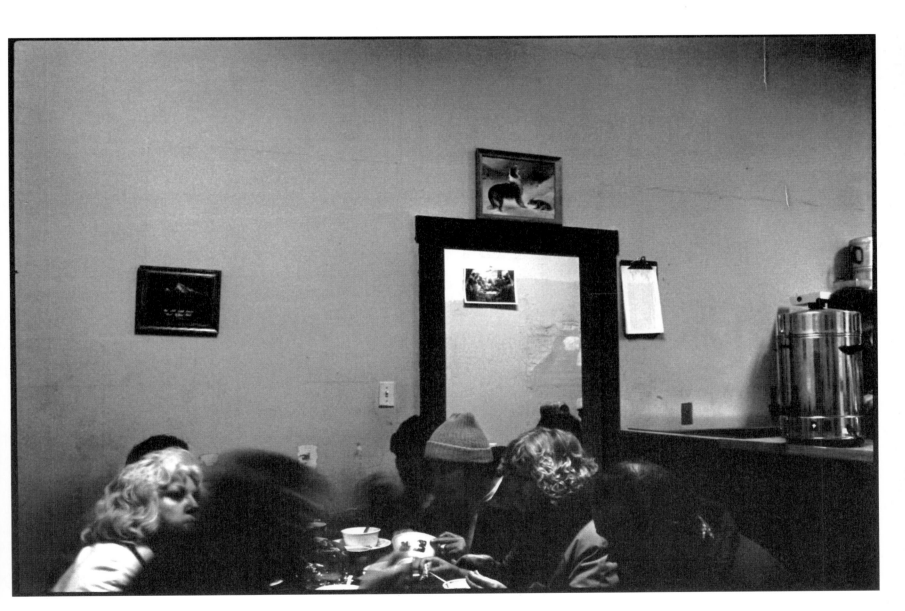

Fig. 23. Men's dorm, Lutheran Compass Center

the leader carrying the wooden cross. Carrying the cross was a visual metaphor for evangelism and spreading the gospel, for converting some-one to a belief system; it was a physical expression of bringing the faith to people. Erecting a cross, similarly, was a metaphor for conquering some-thing. At least these were the meanings these acts had in conventional thinking. I had begun to see that evangelism was one of my main subjects and therefore was sensitive to situations that might symbolically represent it. Evangelism connected the missions to the churches. It was the reason church people were in the missions and street people had to sit through the services to eat. Evangelism embodied a theory about the causes of the kinds of lives street people led; it assigned blame for their situation and defined what and who needed to be fixed and how.

I began to photograph cross raisings and carryings whenever I found them. The idea was that these images would enable me to talk visually about evangelism and let me repeat and elaborate on the theme as it appeared in different places (figs. 25-26).

After naming evangelism as a connection between the separate worlds of the missions and the churches that support them, my next job seemed to be to describe the kinds of values these people spread in their evangelical activities. If their goal is to change people's thinking and behavior, then how do they want them to think and behave? I had begun to see that evangelism was more than exotic missionary work. It also meant, for instance, teaching your own children in Bible school, spread-ing the word to them. It seemed necessary to go beyond the missions to the churches.

In the spring of 1986 I photographed a Sunday service at a church involved with the Union Gospel Mission, but it wasn't until the fall that I started making regular visits to the home churches of people who helped at the missions. Fran and Lee Chase, who ran the Bread of Life Mission, gave me a list of names and addresses of participating churches, and I contacted some. In November I began photographing at the Highland Park Church of the Nazarene. A group of people from this church went twice each month to the Peniel Mission, once to prepare lunch and preach a noon service for senior citizens from a low income housing project and once to prepare dinner and preach an evening service for the street people. I photographed the church and a number of activities, including a children's Sunday Bible class that met for an hour just before

Fig. 24. Easter sunrise procession, Pioneer Square

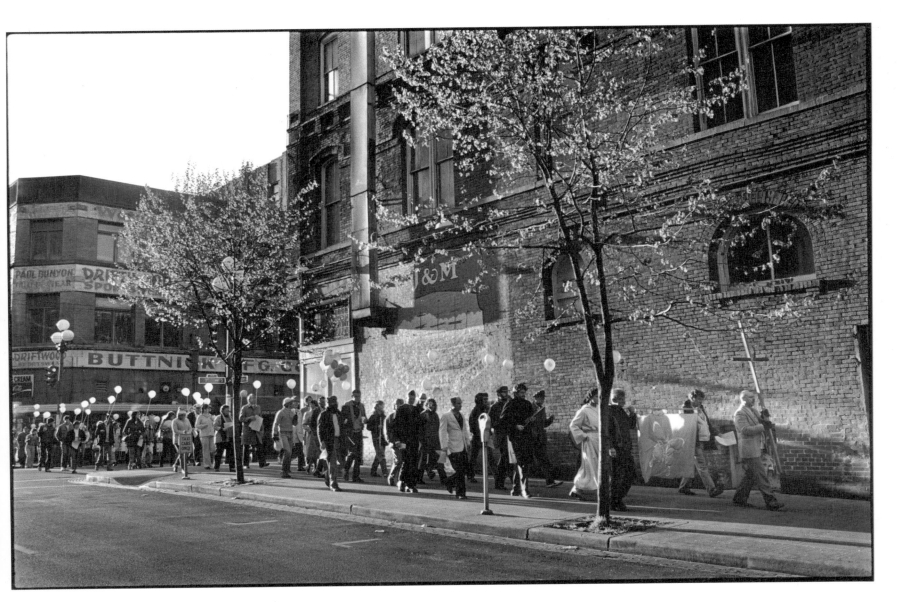

Fig. 25. Gethsemane Lutheran Church

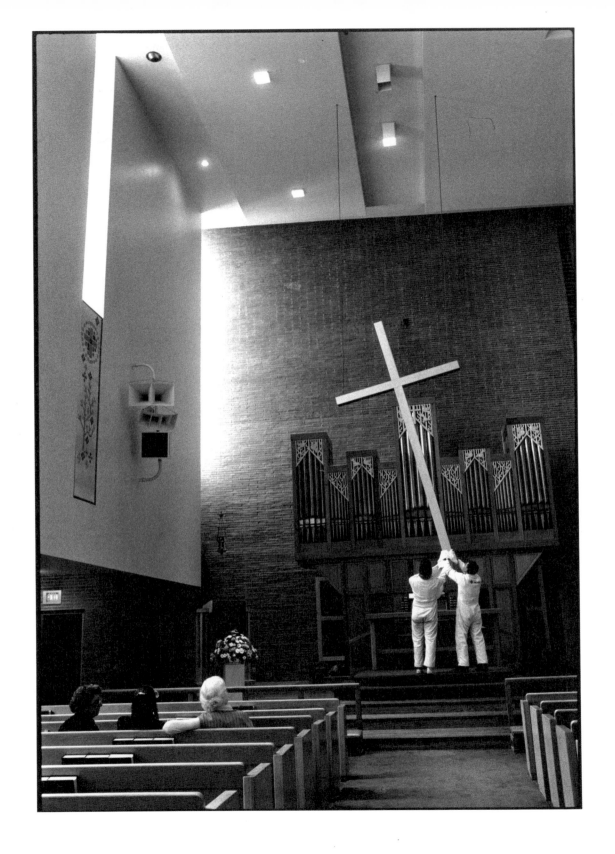

Fig. 26. World Mission room, Gethsemane Lutheran Church

the service, a downstairs meeting room where refreshments were served after the Sunday service, and a women's Bible study group that met once a month in the home of one of the members (figs. 27-29).

In the bible school photograph children sit in folding chairs praying silently and two adult women teachers stand alongside. Behind the children on the wall is a map of the world. Printed along the top is "THE CHURCH OF THE NAZARENE AROUND THE WORLD," explicitly referring to evangelism and the church's practice. The class itself is a form of evangelism, transferring values and a code of behavior to the young. The children sit passively, in the same posture I photographed at the mission services: head bowed, eyes closed, shoulders slumped. This was very different from people's posture when they posed for a portrait. I saw the same submissive, passive body posture and the idea it symbolized — a particular relationship with God (the patriarch, authority, power) — in a number of contexts: in the posture of the street people in the missions, the members of the congregation in the churches, and the children and teachers in the Bible school and on the formal occasion of the ordination of two men to the Catholic priesthood (figs. 30 and 31).

Looking at these photographs together let me make a visual comparison of the passivity and submission obvious in these different contexts and draw analogies from them about some characteristics of the value system Christians were evangelizing. Shifts in meaning were created when the same posture was seen in several contexts: The men in the mission sit passively, their postures apparently expressing submission to God, but more likely evidence of their dependence on the mission personnel for a meal. The children in Bible study maintain the same posture, perhaps in submission to God, but certainly expressing their dependence on their parents and the other adults who run the school.

Placing these images *together* allows the comparison and, hence, the connection. The similarities in the images form a visual link by showing the connection of the passive posture and the idea of submission to a higher authority in different settings that are connected through membership in a larger system of religious organizations. Interwoven are other images (e.g., carrying and erecting the cross and the map of the world on the dining room wall) that connect the idea of evangelism to this attitude of prayer and submissive behavior. I meant to subject this attitude, this value, to scrutiny because many other restrictions on behavior and

Fig. 27. Sunday Bible school, Highland Park Church of the Nazarene

Fig. 28. Meeting room, Highland Park Church of the Nazarene

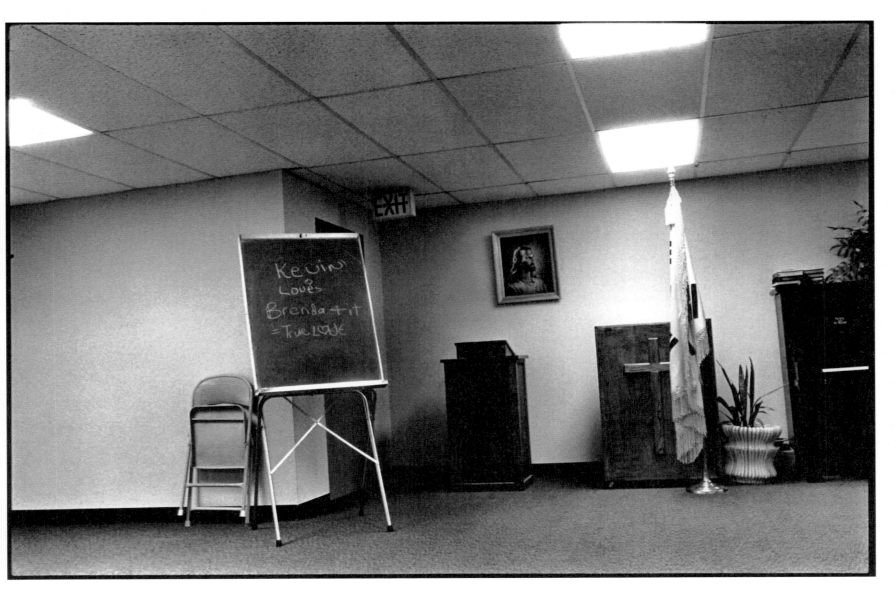

Fig. 29. Women's Bible study group, private home

Fig. 30. Sunday service, Kent Church of the Nazarene

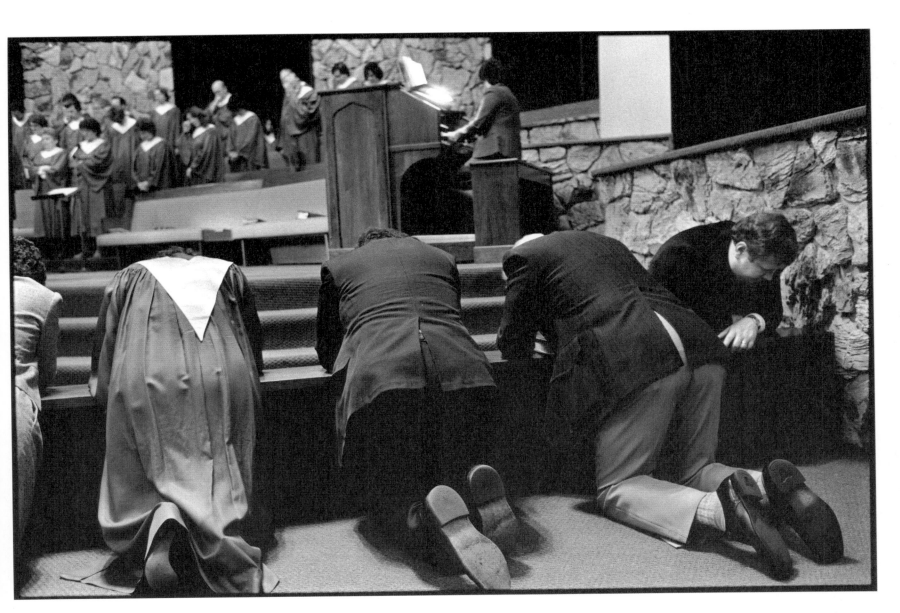

Fig. 31. Ordination to the priesthood, St. James Cathedral

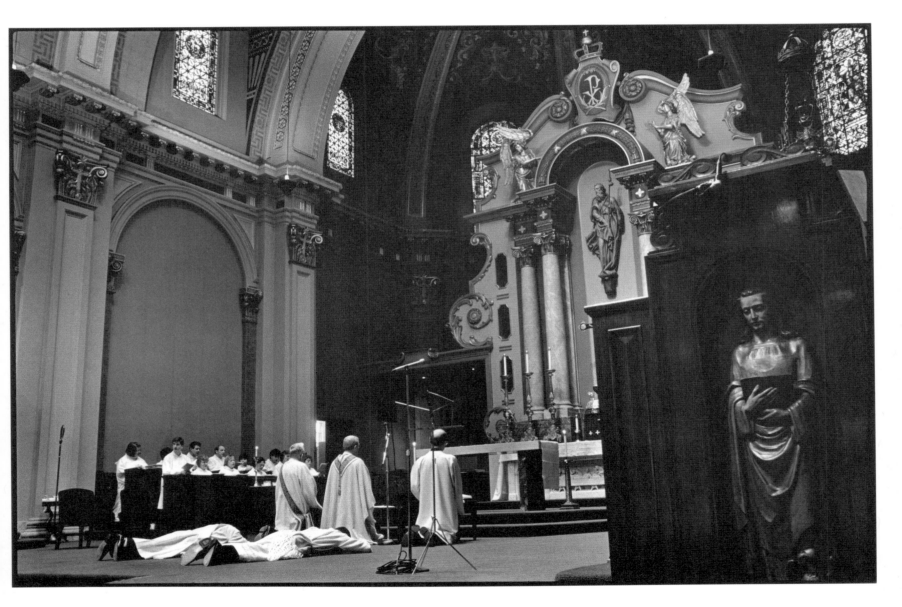

thought come from dictates of that "higher authority," and submission demands an acceptance of them. Churches, of course, legitimate many other relationships besides the one with a god. They set a model for people's relation to agents of authority in the secular world too — the individual to the state and the wife to the husband, for example.

By making photographs that were more detailed and inclusive I could create more intricate networks of connections between those photographs. I could carry through an idea from one photograph to another and examine it in each new context, expanding and developing the idea through a succession of images. The purpose of creating symbols and juxtapositions of symbols, other objects, and behavior was to explore an idea such as evangelism or hierarchy and power as seen in the missions by comparing it to what could be seen in the home churches and Christianity in general. I found myself dealing with very different photographic problems. How, for instance, could I visually express the idea that subjection of the will is valued and encouraged by Christians, that it is what true believers are asked to do? A symbol (or combination of symbols or details) need not be a main element in each photograph. It might be a minor background detail in one and appear in a more dominant position in a later photograph.[14] When you compose your images to give a quick read you limit your ability to include the kind of quiet detail that resonates between photographs. Juxtapositions seem obvious and heavy-handed because the possible associations between photographs and elements in them are less richly layered.

Expanding Boundaries

Up to this point I had confined myself to the missions' circle of churches, those churches that directly contributed either money or services to one or more of the missions. The first photograph I made that took me outside that circle was of a cross raising at the Korean Christian Church (fig. 32).

I lived a block away from the church at the time but hadn't contacted them, because, as far as I knew, the congregation had nothing to do with the work of the missions and shelters. One day, on my way to my car, I saw a crane lifting a large cross and I photographed the cross as it was placed on the roof. I included the cross-like telephone poles and surrounding neighborhood in the frame. This photograph marked a further expansion in the conceptual circle that defined the boundaries of

Fig. 32. Korean Community Christian Church

the project for me. I was now interested in the subject of evangelism, whether or not there was a direct link to the missions, and I continued to use the motif of cross raising as a symbol of evangelism. I thought the idea of a Korean Christianity itself testified to an effective cross-cultural evangelism, and photographing the raising of the cross brought these themes together.

In some ways, redefining the project's boundaries let me introduce a kind of randomness into what I photographed. I would read about some religious event in the newspaper and go see if anything there could tell me more about my themes. When I got there I photographed what I saw as best I could with the formal language I was developing. The rhythm of the project shifted, as did the kinds of knowledge I had about the religious communities in the area. I made new mental maps connecting the churches and organizations to each other. The nuclear disarmament marches, for instance, and the specific network of churches that took part in them, were inscribed on my map now, as were the churches that provided for AIDS counseling and allowed gay and lesbian groups to meet in their facilities. I was developing a more general view of religion. I began to photograph these activities and added them to those of the missions and the church groups directly connected with them.

Mass Communications

One event that I found listed in the newspaper and went to photograph was a Catholic mass broadcast "live" from Rome to Our Lady of Fatima Church in Seattle (fig. 33). At the mass at Our Lady of Fatima the video image of John Paul II was projected on two large screens at either side of the altar at the front of the church. The empty altar (an empty stage, really) was covered with a white cloth. High above the altar hung a statue of the ascendant Christ and above that a domed skylight. Two banners hung vertically from the wall on either side of the stage. One banner listed "THE GIFTS of the HOLY SPIRIT," from wisdom to fear of the Lord; the other, "THE FRUITS of the HOLY SPIRIT," from love to self-control. Fear was viewed positively, as a gift, and seemed connected to, perhaps required for, self-control. Fear of the Lord was an incentive to be good.

Self-control, in religious terms, is not perceived as a general quality but refers to specific things people are asked to control. When we inter-

Fig. 33. Mass broadcast live from Rome, Our Lady of Fatima Church

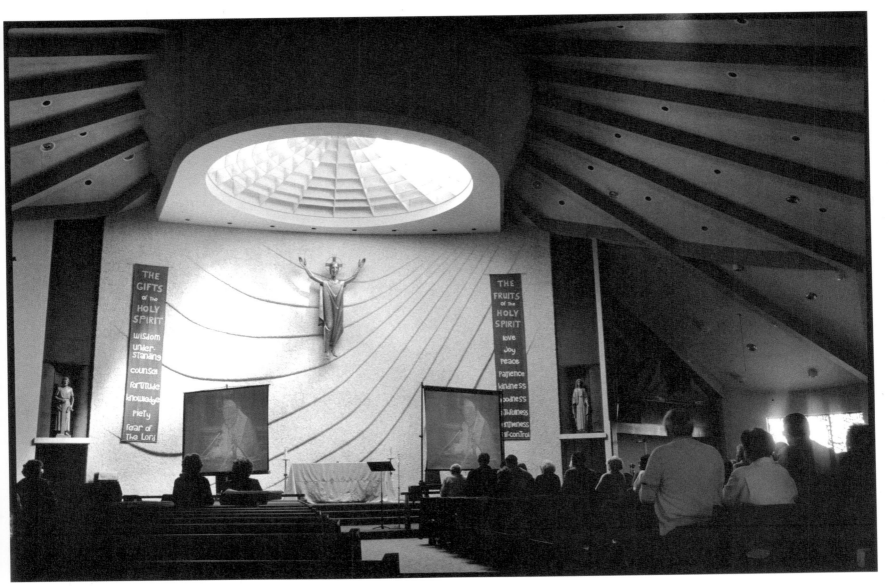

nalize these values, we develop self-control. It's what happens to newspaper photographers when they internalize the conventional newspaper concept of a "good" photograph and begin to think of the photographs that manifest this concept as "good." They no longer need fear their editor sending them back to reshoot a picture as an incentive to make such photographs. Having internalized the idea of the good photograph, they will control their own work, believe in the aesthetic, adopt those values so that when they make such an image it "feels" like a good picture. Ultimately, however, what's good is whatever the organization requires people to do, whether that organization is a newspaper, a church, or a system of government.[15]

The scene at Our Lady of Fatima seemed strange to me, unlike any service I'd ever been to at a Catholic church. No priest stood at the altar. People responded instead to a television image. They stood up, sat down, knelt and prayed, and said, "Amen" aloud, just as though a priest were officiating in person. But a video image stood in for the priest. At a mass or other worship service in a church we expect to see the mediator, the priest or the minister, in the flesh, not as a two-dimensional image on a big screen. Television evangelists such as Jerry Falwell, Oral Roberts, and Jim Bakker have made television religion familiar. But they usually broadcast into private homes and are watched by individuals, or small groups of friends or family, not by a congregation sitting in a church. At Our Lady of Fatima a video pope mediated between God and people. It was like being in a classroom with the teacher on a television monitor or having a computer call you on the telephone. The set-up insulated the pope from any contact with or intervention from the congregation. A video minister is less accessible than a human one.

The mass was billed as "live," which was probably significant. When the parishioners at Our Lady of Fatima saw the pope raise the chalice on the video screen, they understood that somewhere in Rome, at that very same moment, communion between the pope and God was happening. Had they thought otherwise, the event might have seemed like a television news account of a mass the pope had already performed elsewhere. The televised space and activity in Rome were sacred, thus the altar and activity in Seattle became sacred. A videotape of a mass is just that — a recording of a sacred event that has already happened. But everyone in the church knew that this particular ceremony was live, and that knowl-

Fig. 34. Funeral reception for Michael Otto, Holy Names Academy

edge informed their experience of the event. "Live" video was less disembodied psychologically than if the pope was in bed sleeping when Seattle watched a recording of a Roman ceremony. The video pope, transmitted by a profane technology, seemingly so out of place in a Catholic church, had become the vehicle through which an authentic, sacred ritual was enacted. The same church that forbids the use of modern reproductive technology in the form of contraception had transformed the power of modern communication technology to its own ends. I composed the photograph to describe the scene in a straightforward, deadpan style, hoping that the incongruent mix of elements would convey the sense of strangeness I felt.

This photograph belonged to a broad category of "images" I had constructed for myself that included self-image, ideal image, photographic image, projected video image, painted image, and any sort of mental or physical picture and its use and making in the context of religion. When I photographed, I often included any sort of image I found where I was working, however obscure its meaning or connection to my other ideas might have seemed at the time. A great variety of images coexisted in the photographs of the religious activities I was studying, including photographs from funerals.[16] I became interested in events that pulled ordinarily non-religious people into the orbit of organized religion. Death was one such event: even non-religious people like me occasionally entered a religious setting to go to a funeral. Marriage is like that too. You go to a friend's wedding and there you are in church. Sometimes the people getting married aren't even religious, yet they still get married in church. It's what's done or what their parents want.

I had photographed Michael Otto and Elaine Cohen for *Pacific*, the *Seattle Times* Sunday magazine I was working for then, as part of a cover story on AIDS volunteer workers. Michael had AIDS, and Elaine was a volunteer with the Chicken Soup Brigade, whose members visited homebound AIDS patients. The two became close friends during Michael's long illness. Six months after the story was published, Elaine called to say that Michael had died and to ask me, as a favor, to photograph the funeral for her (figs. 34 and 35).

At the reception at the Holy Names Academy following the funeral, a flower arrangement surrounded a framed photograph of Michael on a sunny day sitting in a field with Mount Rainier behind him. He looked

Fig. 35. Funeral reception for Michael Otto, Holy Names Academy

carefree, healthy, very different from the image of Michael I held in my mind — that of a fragile, dying man. Alongside it, another bouquet of flowers tied with a ribbon surrounded a picture of Jesus, a stylized painting of a man about Michael's age but from "olden times." The cheery photograph of Michael looked modern, in striking contrast to the ancient robes typical of religious paintings and sculptures and the medieval robes priests and ministers wear. The contrast made me think how out of place conventional religious imagery can be and how conventional religious robes can be a visual trigger for the feeling of a holy aura.

I continued to visit some of the missions, not so much to photograph (although I always filled requests for portraits) but to have coffee and keep in touch with particular people I liked. I still made other kinds of photographs than portraits at the missions, and occasionally, as happened at the funeral service for Mary Witt, these photographs opened up new areas of thought.

One morning I stopped at the Lutheran Compass Center to say hello. I hadn't been there for almost a month. Dianne Quast, the chaplain, told me that Mary Witt, a well-liked counselor who worked with the women residents, had been killed in an accident a few days earlier. Mary was on her way to Montana to visit relatives when the accident happened. I went to a memorial service in the chapel that afternoon. Some of her family had driven to Seattle from Montana to be there.

Dianne put a large photograph of Mary and votive candles on a table covered with a white cloth and a red Lutheran banner (fig. 36). During the ceremony for Mary, she asked people to come forward, light a candle, and say something about Mary: She was a good daughter. She was a good friend. She had a wonderful sense of humor. She was committed to her work. She will be missed. The altar was a makeshift, personalized, public shrine that marked off a sacred space in which a ceremony could be improvised. When I photographed it, I included a tapestry of The Last Supper pinned to one wall of the room: another table, another ceremonial cloth, another last and final offering. Dianne had pushed the chairs back to clear floor space and create a second altar — the table with the candles and the photograph of Mary — ignoring the traditional altar on its raised platform, enclosed by a rail. This seemed an apt metaphor for the way some people were reevaluating old rules and church practices. In the process of reevaluation, shrines and ceremonies must be improvised and remade because the old ones no longer do the job.

Fig. 36. Memorial service for Mary Witt, Lutheran Compass Center

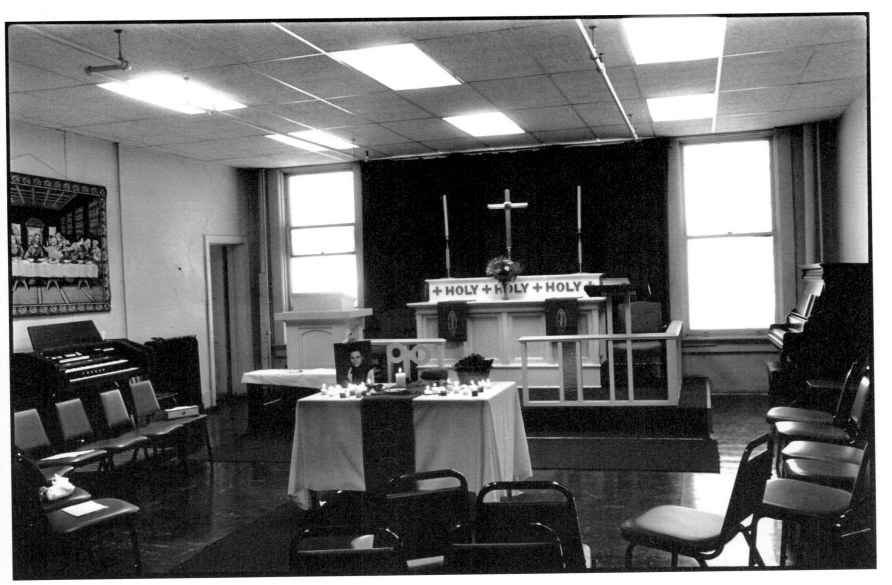

I began looking for altars, whatever form they took. The generalized idea of an altar as a place of transformation was an idea that I carried in my head when I photographed, so I was sensitive to any scene with an altar or any object that physically resembled one or could be thought to function as one metaphorically. Many of these settings were not conventional church altars or sacred spaces but resembled such spaces physically or in some other way suggested them. Whenever I saw something that seemed to function as an altar I made a photograph that described what it looked like and where it was located. I understood the altar as an object that designated a sacred space and indicated that something significant was happening there, that some transformation was occurring.

Secular Space Another newspaper listing that I pursued was the 25th Anniversary Celebration for Archbishop Raymond Hunthausen, at Hec Edmondson Pavilion on the University of Washington campus, where I had photographed many college basketball games for local newspapers. The listing caught my attention because the event seemed likely to involve making some secular space sacred by constructing an ad hoc altar.

The celebration was called an Interfaith Prayer Service for Peace, and the secular meeting ground provided a neutral space that belonged to no particular sect. When religion moves from its own sacred places into the secular world it sacralizes secular space for its own purposes. The religious functionaries perform a ritual, make an altar, and declare the space sacred, thereby creating both a place for a ceremony and religious meaning outside the conventional context or space of the church, where that meaning would be automatically present.

The master of ceremonies was a rabbi. The participants included a Christian boys' choir from south of Seattle and a huge adult choir. A procession of local religious leaders, separated from the crowd by a curtain, formed in the back of the pavilion. Priests dressed in robes ran here and there with walkie-talkies, coordinating the ritual.

At the front of the pavilion Archbishop Hunthausen sat on a stage in a wicker armchair next to a potted tree (fig. 37). Behind him in ascending rows were a couple of hundred choir members, and hanging above them was a huge screen with a live video projection of Hunthausen's face. A shiny gold cloth skirting the edge of the stage transformed it into an

Fig. 37. Interfaith Celebration with Archbishop Raymond Hunthausen, Hec Edmondson Pavilion

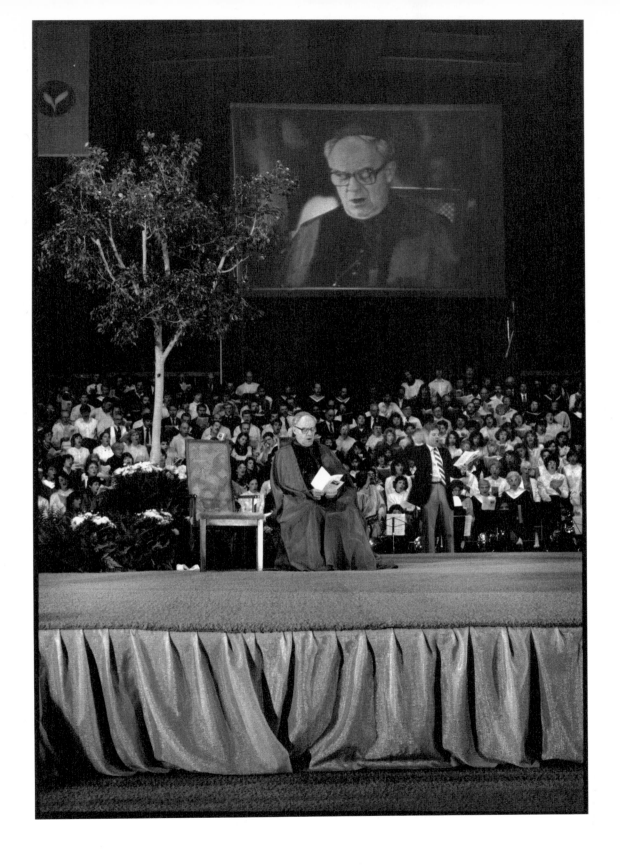

enormous altar. The meaning of the event lay in transplanting elements from a church to a portable stage in a sports arena. Of all the elements in the photograph, the one that was at home in a sports arena was the video screen and its larger-than-life, real-time action and instant replay.

People usually find that they have to make compromises when they bring their sacred activities out into the secular world. They make concessions to the secular in order to bring the sacred to places and people it wouldn't otherwise reach (which of course is one of the challenges of evangelism). When I composed the photograph of the boys' choir standing backstage at the Hunthausen celebration (fig. 38), I included the "CONCESSIONS" sign with its large arrow because I wanted to put the idea of concession into the symbolic world of my project, where it could resonate with other photographs. I also saw a play on the word "confession," a Catholic sacrament. (The sign actually pointed to the food stands open during basketball games.) The boys in the choir wore identical robes and looked like little angel cutouts. Since the time I photographed the Sunday school class at the Nazarene church, I had been interested in how children experienced religion, the process by which they were trained in religious values. Several of the ideas I was working with had come together in this situation, and I photographed the boys' choir so as to include them all.

Normal Photography

I worked very deliberately at this stage in the project, having finally internalized many new ways of organizing elements in the frame. I could perform them more intuitively now. I was fluent in this new language. As a result, I worked with little or no hesitation. I consistently included more elements in the frame of each picture I made, but controlled the framing, vantage point, and timing. My old ways of working — ways that had worked so well for me as a photojournalist — were meant for saying other sorts of things than those I now wanted to say. The formal and conceptual tools and models I now used furthered, rather than stood in the way of, the ideas I wanted to express. I began a year-long roll in which I had the language to connect and explore ideas in the photographs. At least, that's how it seemed.

The physical sense of "rightness" I had felt as a newspaper photojournalist had reemerged, but the result was different. Each situation was

Fig. 38. Christian Boy's Choir, Hec Edmondson Pavilion

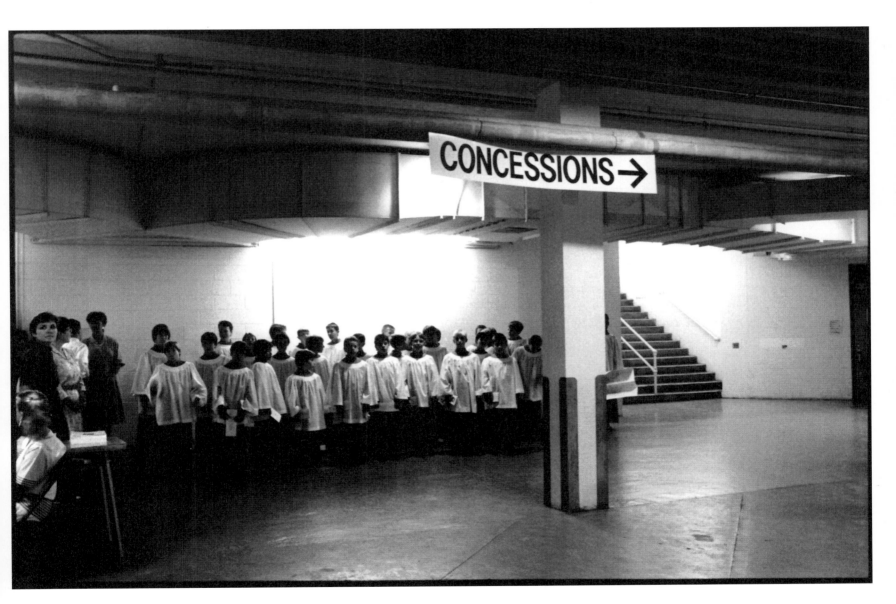

a puzzle: how do I translate its relevant aspects to film? Each image solved a puzzle. My new language assured me that each of those puzzles had a solution. I felt the ease and assurance historian of science Thomas Kuhn had described as characteristic of scientists doing "normal science,"[17] working within a paradigm, confident that they are working on a legitimate problem with a guaranteed solution — what Kuhn called a "puzzle."

One thing that was particularly noticeable was how much more efficiently I worked. I no longer felt as if I was stumbling around. Instead, I had a clear idea of what I was doing with this project, what it was about. Whenever I went to photograph something, I usually made useful, coherent photographs that contributed in some way to the work I was developing. I had no problem connecting the different events I photographed during this period: a funeral service, a peace march, a phone crusade, a birthday party in a retirement home, a first communion, a faith healing, a wedding, a televised mass. I still had specific questions I wanted to answer: What do women do in these church activities, especially in the ceremonies, like weddings, that are important to their lives? What are the connections between the churches and political and social issues? ("One nation under God," I reminded myself.) The news media were part of the process; how did they "cover" religion? Having a more appropriate visual vocabulary than the one I began the project with, I felt I could begin to answer some of these questions visually. The project seemed doable. My ideas about how things should be done, how the photographs should be constructed, jibed with my thoughts on the importance of what I saw.

Televangelism I was still visiting the Bread of Life every few weeks, mainly to see Bud Cripes. Bud and I would walk across the street to the Elliott Bay Bookstore for coffee and a scone. He was a retired mission worker, someone who works and lives in missions as a career, but still came by the Bread of Life one or two days a week to help out. He had worked as a cook and lived at a mission in Indio, California, for years, after sobering up. Then he came to Seattle and worked as a cook at the Bread of Life for nine years until he retired. He was very religious, a born-again Christian.

At one of our coffee sessions Bud told me he was a longtime volun-

teer for the Billy Graham telephone crusade. The crusade was nationally televised, and Seattle was one of five call-in centers around the country whose phone numbers were continually flashed on the screen during the program. The volunteers, buried in little booths, talked with strangers and "converted" them, using mass technology to spread the word.

The Seattle call-in center was at the North Seattle Church of the Nazarene. The center had one hundred phones set up in the auditorium of the church school and received over two thousand calls a night. Volunteers attended a three-hour training session during which they listened to tapes about helping callers with stress and alcohol problems and learned how to talk with people who threatened to kill themselves. Callers pay for their own phone calls. The longest call Bud ever took lasted one hour and ten minutes. He said the crusade people liked them to keep the calls under five minutes, but he always listened for as long as he needed to, especially if he felt the person was ready for salvation, close to having some kind of conversion experience and to accepting Jesus Christ as their Savior. Bud memorized long passages of scripture so he wouldn't have to spend time looking them up while he was on the phone. He thought there was a barrier that needed to be broken down before someone could listen to the Lord and that the height of the barrier was directly related to how wrapped up in their own problems people were.

I called the pastor of the North Seattle Church of the Nazarene and asked if I could photograph the event. He said I was welcome to come by and talk to the "Billy Graham people," who would have to give me permission. I went on a night when Bud was there, thinking he could vouch for me if I needed it — and I did. The Billy Graham people were young men who wouldn't do anything without permission. It took them half an hour to get through to the national people, who then said it was probably okay for me to photograph. While they were checking with national headquarters, I stood in the hallway and talked to volunteers on a food break or prayer mission (praying for callers who had requested that kind of help). A prayer area had been marked off. A sign pointed to a classroom that served as a church nursery on Sundays; they hadn't taken the sign down for the phone crusade. A group of women were praying ("for my husband to sober up and receive the Lord" and similar requests). I asked if I could photograph them, and they said, "Oh, yes, it's just the phone room you can't photograph until we hear from national headquarters."

So I set up my tripod. The portable partitions in the hallway defined a sacred space for prayer. I photographed the women as they prayed and included the nursery sign on the wall to connect women and religion with child care. I was particularly interested in exploring that relationship, the volatile issue of the obligation of women to children. Abortion, for example, is often defined and argued in religious terms that embody assumptions about who women are and how they should behave. If I recognized something in a situation that seemed to relate to these assumptions, then I included it within the frame (fig. 39).

I was finally allowed into the phone room (fig. 40). It was partitioned off into dozens of little cubicles. Each volunteer sat in one with a phone and three cards. (One read "language," another "suicide," and a third "needs assistance." If a volunteer held up a card, then someone multi-lingual or with more experience came to help with the call.) A big cross hung on the back wall next to a map of the county labeled "THE WORLD IS OUR PARISH."

At the front of the room was a stage from which I photographed the pattern of workers in their cubicles. I also photographed individual volunteers but knew, even as I made these pictures, that I wasn't interested in photographs of individuals working the phones. I didn't want to make closeups of "interesting faces" or of moments of "honest emotion." I made photographs of individuals mainly because I wanted to give prints to Bud and the North Seattle Church, and I thought they would like them as well as my photographs of the entire operation. I was now less interested in photographing particular volunteers and more interested in photographing the group, the same shift of interest that had occurred for me during the mission prayer services. It was more important to me to show what these people were doing together and the kind of space they were doing it in. The scene reminded me of the choirboys at the Hunthausen celebration: identical little boxes, identical little choir robes, as though these people had been molded, shaped to fit the church. The visual similarities became clues to similarities of social organization.

I also realized that making photographs of an entire scene is often less threatening to people than making photographs of them as individuals. I suppose they worry about how you will use the picture and so are more self-conscious. In overviews, made from a distance, the people are tiny and the group activity, rather than the individual personalities,

Fig. 39. Billy Graham Phone Crusade, North Seattle Church of the Nazarene

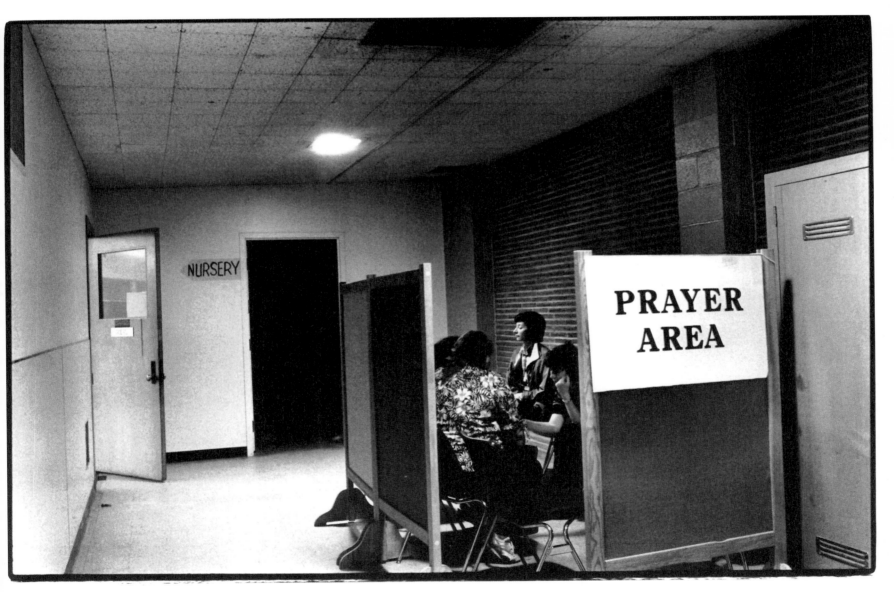

becomes the subject of the photograph, so the individuals think they have less to worry about. I have the same sensation when I'm photographed in a group.

I photographed from the stage in order to point the camera downward, to accentuate the pattern, the repetition of the volunteers bent over their telephones. The high vantage point let me see inside the cubicles, each person making notes, talking on the phone, one after another, rows of them. Using the telephone and television to make money and converts was an organized effort intended to influence people's thinking and, ultimately, their actions.[18]

Shaping Children

The idea of "image" became an important thread through most of the photographs: the image of the ideal person, the image made by the camera, and the connection of those images to actual events or people. One implication of image (as in the common expression "self-image") that interested me was that people are molded or shaped to fit one, or, more important, that they mold or shape themselves to fit. In this way, they are controlled by those who created the image they are conforming to. This idea is reflected in several of the photographs, especially those of children and those that involve the ideal image to which women in this society are expected to conform. This ideal came to be embodied for me in the symbol of the white dress.

The day after Mary Witt's memorial service I called the Christian Faith Center, whose pastor, Casey Treat, broadcast a thirty-minute local television program every week. I originally contacted the group because of my interest in how religious organizations use the media. When I visited the center, however, I found it had a Christian elementary school, a Sunday school, and an elaborate nursery school system to watch children while their parents were in Sunday worship.

The Sunday school (figs. 41 and 42), for fifth-, sixth-, and seventh-graders, was called Children's Church and lasted for two hours. The children's pastor, Orvel Kester (who had several adult helpers), was hip and funny and the kids liked him a lot.

Every week Children's Church held a scripture jigsaw puzzle contest, the boys against the girls. The kids had been given a Bible verse to memorize the week before. On Sunday morning everyone had a few

Fig. 40. Billy Graham Phone Crusade, North Seattle Church of the Nazarene

minutes to look at the verse, which was printed on the puzzle, before the pieces were mixed up. Each team then designated a person who had one minute to put the pieces together to win.

The verse on the puzzle in figure 41 was about men and women being made in the image of God: "God created man in His own image, in the image of God created He him; male and female created He them" (Genesis 1:27). I liked the idea of someone's image being bits of a puzzle you had to put together to win the game. The puzzle was placed on a curtained stage at the end of the room. I thought the stage might have the feel of an altar when I combined it with some of the other "altar" images I had accumulated.

So I photographed a little girl bending over an altar, piecing together this verse about her being made in the image of Christ, as another girl cheers her on and four adult male sentries watch, one of them keeping time. I wanted to get at some of the things that went into the process of piecing together an identity and becoming someone. A young girl learns the values adults want her to learn by playing a game that turns the learning into "fun." She's bent down in a submissive posture. She learns she was created in the image of Christ who, she also learns, is part man and part God. The image of Christ prescribes values, behavior, and roles, so she's learning those too. She's observed in this activity by the sentries, the male figures of authority. Another girl, a peer, cheers for her, encourages her, and participates in the learning process. These are concrete and real influences in the creation of her self-image, factors she must continually contend with as she grows and becomes an adult. She won't simply decide what the real her is going to be and then become her. Other people, who have a vested interest in the result, do what they can to make her the person they want her to be.

If the stage was an altar and an altar is a place of transformation, then who was this girl being transformed into? A Christian? Who or what was transforming her? Church leaders? Parents? The other children in the Sunday school? Was she learning the church's image of Christ and learning to think of herself as someone who is supposed to behave like that? We transform ourselves in these same ways. We internalize the idea of what is good. You want to be the image of Christ or Christ's image of what you should be. You want to become what your church wants you to become.

Fig. 41. Children's Church, Christian Faith Center

Fig. 42. Children's Church, Christian Faith Center

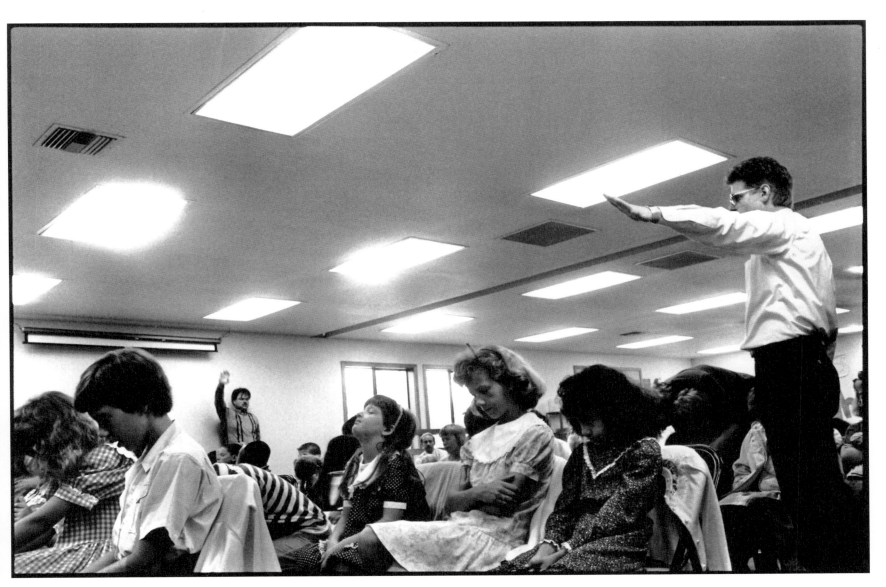

The White Dress

I read an announcement in the newspaper's religion page calendar for a birthday party at the Josephinium, a Catholic retirement home in downtown Seattle. The party was to celebrate the 105th birthday of a resident of the home. There would be entertainment, and both the mayor and the Catholic adjutant archbishop would attend.

In a photograph I made at this party, a woman in a white dress (a professional singer) is blurred and vague (fig. 43). Solid women, more sharply focused, watch her. Some of the women are smiling, but at least one of them is scowling, maybe even disapprovingly. A religious statue is behind them: it looks like Joseph is holding up the baby Jesus so that he can get a better look at the lady in white. I had my camera on a tripod, set to a very slow shutter speed to ensure that the movement of the woman in white would be blurred and ethereal, maybe even translucent. I thought of her as a hazy ideal, an implicit, probably unattainable form. The whiteness of the singer's dress carries all the connotations of purity that go with that color, but her shape is "womanly," large-breasted, so that it's somewhat ambiguous: it's not quite clear how innocent she is. The ideal is blurred. Ideals are probably always in transformation, but we all know some things about religion's ideal woman: she's pure, nurturing, and obedient to God.

I sought out aspects of ceremonies that involved the relationships of women and religion, situations that expressed ideas about a woman's role and place. I photographed a wedding at the Central Lutheran Church (fig. 44). The bride stands before the open door in her beautiful, white bridal dress, pausing as she is about to enter the church and walk down the aisle and be married.[19] As a bride, even if you don't accept the system of beliefs and practices symbolized by that white dress, you're forced to deal with it because it's so integrated into Western culture.

Earlier in the project, I'd made a photograph in a meeting room of a Nazarene Church that contains a podium, a portrait of Jesus on a wall, a flag, a plant, and a chalk board on an easel on which someone had written "Kevin Loves Brenda & it = True Love" (fig. 28). I thought the statement was funny, obviously a prank. But, placed where it was, it posed questions about religion and "true love." What constitutes true love? Which of our desires and ideals are learned? When someone decides to marry, what expectations does that create, especially for a bride?

I was thinking of that photograph, and the things it had suggested to

Fig. 43. The Josephinium

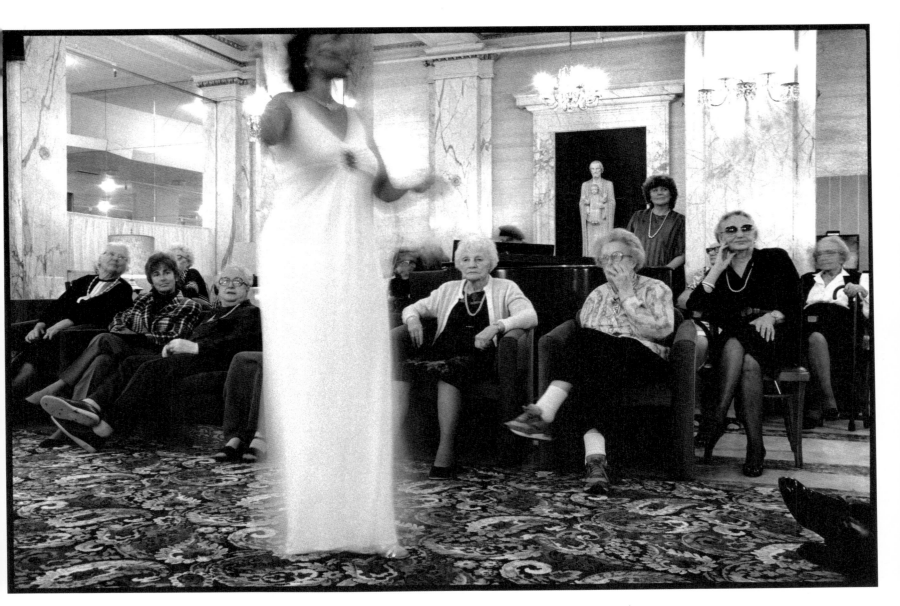

Fig. 44. Wedding, Central Lutheran Church

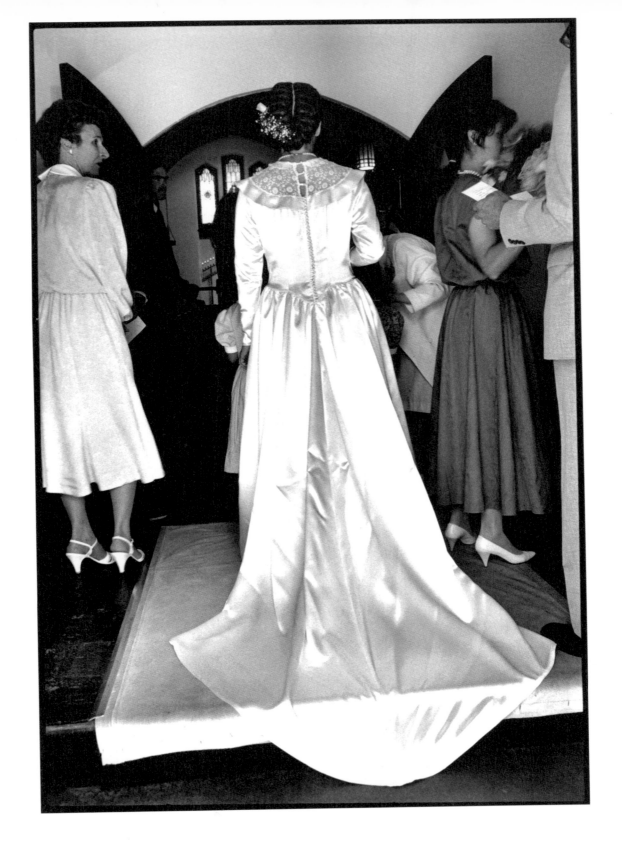

me, when I photographed the wedding at Central Lutheran Church. I knew I didn't want to photograph the woman actually getting married, the ceremony itself. I wanted to photograph her as she waited to walk down the aisle, her pause at the door, or at least the pictorial suggestion of a pause, because I had some ideas about that pause, independent of what her own thoughts might have been.

For me, the pause symbolizes taking stock, thinking about what's at stake in this action. It's not necessarily a hesitation, although it could be that. I was using this picture not to document the fact of a particular wedding but for my own purpose, which was to question some deeply embedded cultural perspectives about women. People negotiate their lives within these larger social forms, and how they deal with these things had become interesting to me. At the end of the aisle is the altar where this woman will be transformed into a wife.

The implications of that transformation are far reaching. What I wanted to get at was that you don't just get married: When you get married, people will think of you as "married," as, in some important sense, a different person, or a different kind of person, than you were before. I was interested in the point of intersection between religion and ideas about what it means to be married. These days, brides who make traditional vows consciously decide whether to promise to obey, as well as love and honor, their husbands. If they don't take "obey" out, it will be in there. It could, after all, be the other way around, "obey" being left out unless someone asked for it to be included. Tradition thus subtly counsels "obey." But now brides consider the question. I used the bride's pause at the church door to suggest a hesitation, a conscious stopping to think about these conflicting feelings, values, and desires. She hears in her head the voices of other people, of institutions. She carries on an internal dialogue with these voices. We understand her situation only when we understand these other relationships and considerations. To get at this idea, to suggest some of these other voices, I put the photograph in the context of the other photographs in the essay.

In the photograph I made at the Josephinium birthday party, the white dress is smeared on the film, an unfocused, insubstantial form. The bridal dress from the Central Lutheran wedding was not photographed that way. Instead, that image describes the dress in sharply focused detail meant to induce a meditation on the gown itself — the sensuous satin, the

way it falls and folds and reflects the light, all those covered buttons. By containing the dress and making it — not the bride — dominant in the frame, I intended viewers to pause, to study it, and to think of it in the context of the white dresses and white robes in other pictures.

The white dress came to symbolize for me the definitions women do battle with, the molds they have to fit into or resist, all the obligations that come with the definitions of gender current in American society. Of course, not everyone does battle with these definitions. For some, they are a ratification of a greatly desired status.

I photographed a first communion ceremony, which was in Spanish, at St. Mary Catholic Church and the reception afterward in the church auditorium (fig. 45). The young girls participating wore beautiful, long, elaborate white gowns their mothers or grandmothers had sewn. In one photograph, a girl runs across the floor. She is slightly blurred on the film from the speed of her own motion, blurred in her white dress like the singer at the Josephinium. She does not pause or reflect or doubt; she is happy to take this step toward conventional Christian womanhood.

Women and Children

In addition to the Children's Church at the Christian Faith Center, I also photographed the elaborate childcare operation for the younger children. The center put a lot of energy and resources into providing for children while parents were at worship. This was one of the ways they expressed the importance of their idea of "family." Church literature always featured photographs of Casey Treat and his wife Wendy and their two children posed in the same way political candidates and their families pose for a "happy family" publicity shot.

Every Sunday the classrooms of the church grade school were used for childcare. The children were divided by age, from infants a few months old to third-graders. (After third grade they went to Children's Church.) The intercom carried the worship service into each classroom. On a practical level, the intercom let the caregivers know when the service was winding up, so they could get the children ready to leave. But it also let the caregivers "attend" the worship service taking place in the chapel, at least the way the parishioners at Our Lady of Fatima partici-pated in the mass celebrated by Pope John Paul II in Rome. Women tended the babies and toddlers. If the children were young enough or

asleep, the women sometimes prayed along with the intercom. Otherwise they read Bible stories, played games, or made drawings with the kids. In the photograph I made of the infant room (fig. 46), two women rock babies in their arms. One of the women is rocking babies with her feet as well, as the other prays along with the intercom.

Churches usually assume and support the importance of women's responsibility for children as part of their teaching on the family. Women are often the ones who keep their family going to church. In that sense they are the family's moral guardians; keeping family religious faith alive is defined as their duty. Ironically, one of the elements of religion women have traditionally upheld and educated their children to accept is the subordinate role of women in the family hierarchy. This is a strong and overt element in contemporary fundamentalist Christianity and Orthodox Judaism and tacitly accepted in many religions.

By making visual connections between women, the church, and childcare, I meant to suggest the social connections that make it so complicated to change institutions and ways of thinking. Taken together, the photographs in the project describe the interrelations of various ideas and areas of religious practice. If these ideas on family and church and men and women are just "how things are," then no one can change just one thing and fix the "problem," whatever it is, because that one thing is part of a system that makes it necessary. In figure 39 the sign reads "NURSERY" and points to a separate place and duty for women. Church teaching, traditional understandings, and everyday practice combine to keep women in their place. Changing that place means changing the whole package. To change these ideas or break with them requires an active step because the reminders are embedded deeply and subtly in every aspect of our everyday lives.

Contradictions

Sister Mary, of St. Mary Catholic Church, sometimes officiated at the mass. She told me that the Vatican did not permit this, but she wanted to do it and it was okay with the parish priest, Father Mike. She was deliberately low-key about it and took some precautions. She didn't officiate when a visiting church functionary was in attendance. She didn't challenge the church hierarchy directly and officiated at the discretion of the parish priest. Still, Sister Mary was redefining what duties women should

Fig. 45. Reception following First Communion, St. Mary Church

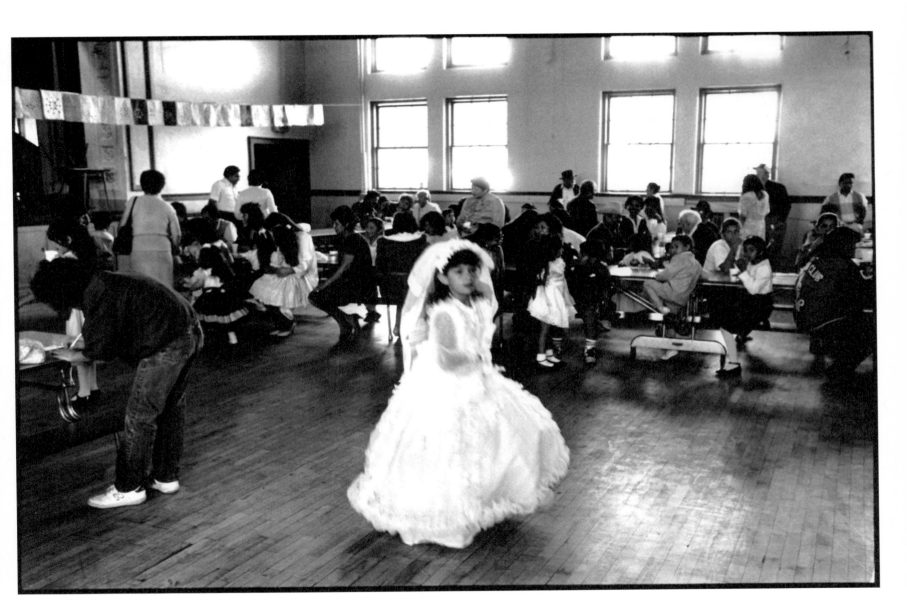

perform in her church, transforming the religious definition of woman, and raising the possibility that power relations within the church could change.

I was increasingly attentive to the places or instances in which contradictions in organized religion were expressed in overt conflict, where there was some kind of struggle with the doctrine, as with feminists in the church. Once I understood them this way, I could see many instances in which religious values and activities contradicted one another and the many ways that religious people dealt with those contradictions.

It was around this time that I learned Dianne Quast was in a personal crisis about her relationship to official Lutheran Church doctrine. She had been Chaplain at the Lutheran Compass Center for several years. She was a lesbian. Most of the top staff at the center knew it, but Dianne's bishop didn't. Her frustration over the tension between her personal life and her position in the church had been building for several years. I remember her wondering whether it was more effective in the long run to play the game and fight within the institution or to break with it and chip away from the outside. We first talked about this when I asked her to recommend some local women I might talk to who, like Dianne, had official positions in the church. During this same conversation I showed her some of the most recent photographs I had made and we talked about them, which is how we began to talk about her problems with the church hierarchy.

I called Linda Larsen, a minister at Central Lutheran Church, at Dianne's suggestion. The congregation of Central Lutheran was a mix of elderly people who lived in the neighborhood and had gone to the church for years and younger families who often didn't live in the immediate area but liked the church's politics enough to make the journey. The church had two ministers, Linda Larsen and John Nelson, under whose leadership members of the congregation made prison visits, participated in a march for an end to nuclear submarines, recycled newspapers for charity, worked with the mentally disabled, and engaged in a long list of other socially responsible works (fig. 47).

During one Palm Sunday morning sermon John Nelson asked the congregation to think about the language they used when talking about God. "We always refer to God as a he," he said. "Did it ever occur to you that God is a she?" After the sermon an announcement was made encour-

Fig. 46. Nursery, Christian Faith Center

aging everyone to participate in the Ecumenical Peace Pilgrimage planned for that afternoon. Central Lutheran was one of the churches along the route and the marchers were scheduled to stop and say a prayer in the church. Following the announcement we sang a hymn whose lyrics were filled with warlike metaphors: "This is the festival of the victory of our Lord. . . ." The incongruities were interesting: a gentle sermon about sexist language in the church, an announcement of a peace pilgrimage that afternoon, and a hymn that likened evangelism to war. Here was a forward-thinking church group, whose members regularly participated in interfaith activities and held socially progressive values, caught in a web of contradictions.

Later that week, I traveled with a group from Central Lutheran to a Good Friday peace march at the Bangor Naval Submarine Base, a two-hour trip from Seattle. Everyone — the usual group representing Seattle churches and other liberal religious organizations that regularly went to these things — gathered at a designated place near the railroad tracks where trains carrying nuclear warheads for the submarines entered the base. For years this stretch of tracks had been the site of protests by various groups who would lie on the tracks to stop the trains from delivering their cargo. The first activity scheduled was a prayer service. A red pickup truck with a huge cross lashed to its side had been parked near the tracks, and a set of portable steps placed on the ground next to the cab formed a tiered platform on which choir members and a few organizers of the event assembled. Other choir members stood in the truck bed. The rest of us gathered around one side of the truck and waited for the ceremony to begin.

Because I was photographing more public events now, events announced in the newspaper, I routinely saw my newspaper colleagues photographing events for the paper that I was photographing for my project. And, since I still worked as a photographer for the *Seattle Times* Sunday magazine, *Pacific,* it meant that some of them were covering these events for my newspaper. I felt simultaneously like an insider and an outsider. It made for interesting comparisons: how we worked, given the different uses we had in mind for the images we made.

Mike Siegel, a colleague at the *Times,* was assigned to photograph the peace march for the newspaper. He knelt in front of the pickup truck with the wooden cross roped to it and photographed the crowd with a

Fig. 47. Palm Sunday procession, Central Lutheran Church

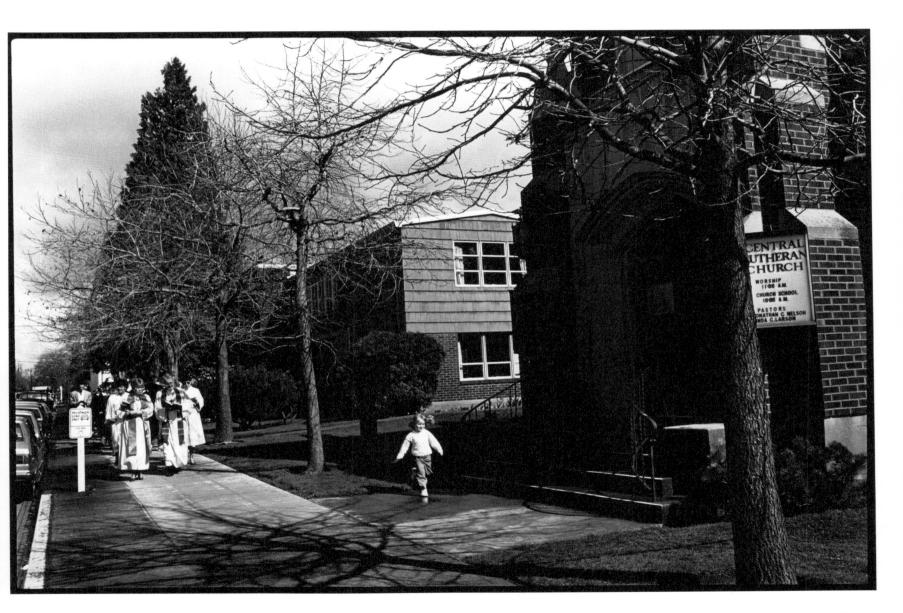

300mm telephoto lens, which meant that, even from a distance, he would be shooting closeups of individuals; the lens's relatively shallow depth of field ensured that his picture would contain no "distracting background." I knew he was looking for something and somebody that would enable him to make a photograph that had "human interest." But I also knew that he would not include context of the kind that now interested me: the pickup truck with a man-sized cross (a makeshift altar) that would figure prominently in my photographs of the event.

Mike's photograph (fig. 48), which ran on the front page in color, was tight on the subject: A young girl holding a wooden cross almost as big as she is. Standing behind her, slightly out of focus but recognizable, is Archbishop Hunthausen in a black cap and tan raincoat. Hunthausen was a celebrity in Seattle, especially after getting into trouble with the Vatican because of his liberal politics. An experienced news photographer like Mike knew that it was important local news that Hunthausen was participating in this event, so he skillfully positioned himself and framed his photograph to include the Archbishop. Good newspaper photographers distinguish their pictures from the run-of-the-mill by introducing variations on standard themes. Children at political protests are an unexpected element (although this variation in news photographs of protests has become a cliché), and that's why Mike included Janice Duffell, age 10, in the frame with Hunthausen.

Again, because the idea of images (all kinds, not just photographs) and their making seemed important to the project, I included Mike Siegel and his 300mm lens in the photographs I made of the pickup truck-altar during the ceremony (fig. 49). I could have cropped him out or made the photograph when he was in another location, but I didn't. I wanted him there. The specific link between the news photographer kneeling by the truck and the other photographs in the project wasn't clear to me yet, but I figured I would try to elaborate the idea in later photographs. I now worked this way intuitively. I kept asking myself how an element in this photograph related to an element in some other one. I remember, for instance, noticing the man in the background to the right of the steps leaning on his cross as though it were a sword, so I made sure to include him when I framed the photograph. The analogy of cross and sword suggested itself as an idea worth exploring visually.

After the ceremony the group began a three-mile walk to the

Fig. 48. Photograph made by Mike Siegel for the *Seattle Times* (original in color).

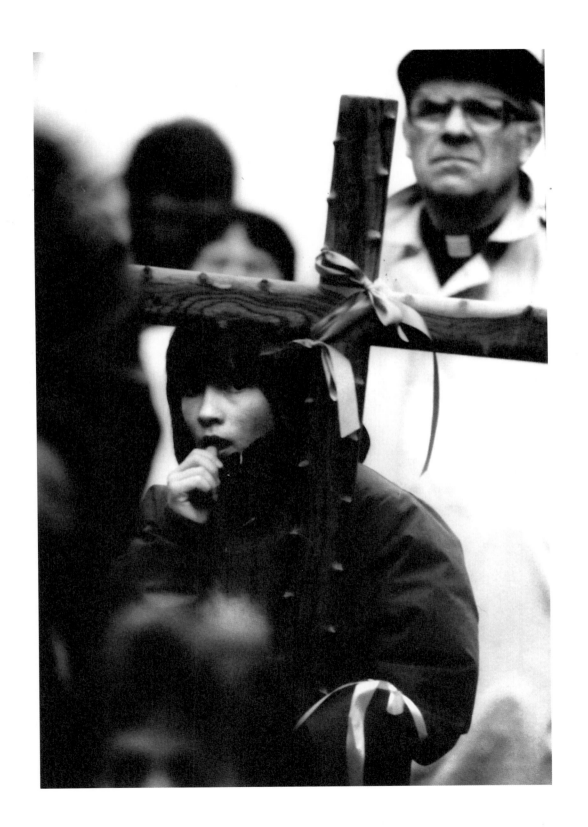

119

northern entrance of the naval base. A few of the men untied the wooden cross from the truck and carried it with them as they walked. All along the route monitors wearing armbands reminded the marchers to stay to the side of the road. There were perhaps a few hundred people, many of them carrying small wooden crosses and yellow ribbons. I walked along with the Central Lutheran parishioners, but I recognized many people from other churches where I had photographed. When we arrived at the entrance, the leaders made the marchers line up across the road from the gate. The monitors in charge of the march took their responsibility and rank seriously.

Unlike the newspaper reporters and photographers who had come to "cover the story," I walked the entire way (they got back in their cars after the ceremony and drove to the gate). I stood with the marchers on the other side of the road, watching the press surround the organizers as they asked to be let in the gate with the cross. The military officials did not allow them inside the base but did let them chain the cross to the gate. It was a media event, and I (who had so often been part of the media and the events staged for their benefit) was watching it from the sidelines. Periodically a monitor walked up and down our line and told someone with their toes on the asphalt to get back on the dirt. The crossbearers stood at the gate having their picture taken for what seemed an eternity, while the rest of us stood watching in the rain. The organizers finally gave the rest of the marchers permission to walk across the street and, using yellow ribbon, tie the wooden crosses onto the iron fence surrounding the base entrance. The monitors warned everyone to step away from the fence immediately to avoid trespassing on government property; they seemed confused about what constituted trespass and took a cautious, conservative tack.

I walked up to the fence to photograph the crosses hanging there (fig. 50). As I framed the photograph, I thought about the military police standing guard on the other side of the fence: I made sure to use the depth of field I needed to get them in focus, and I tried to make as many of them as possible visible between the iron rods. It was still raining and the light was flat and weak, but I wanted both the military and the church (symbolized by the crosses) in the frame. As I was going through these technical procedures a protest monitor grabbed my arm and told me forcefully that I had to move away from the fence. After I made the

Fig. 49. Good Friday demonstration, U.S. Naval Base at Bangor

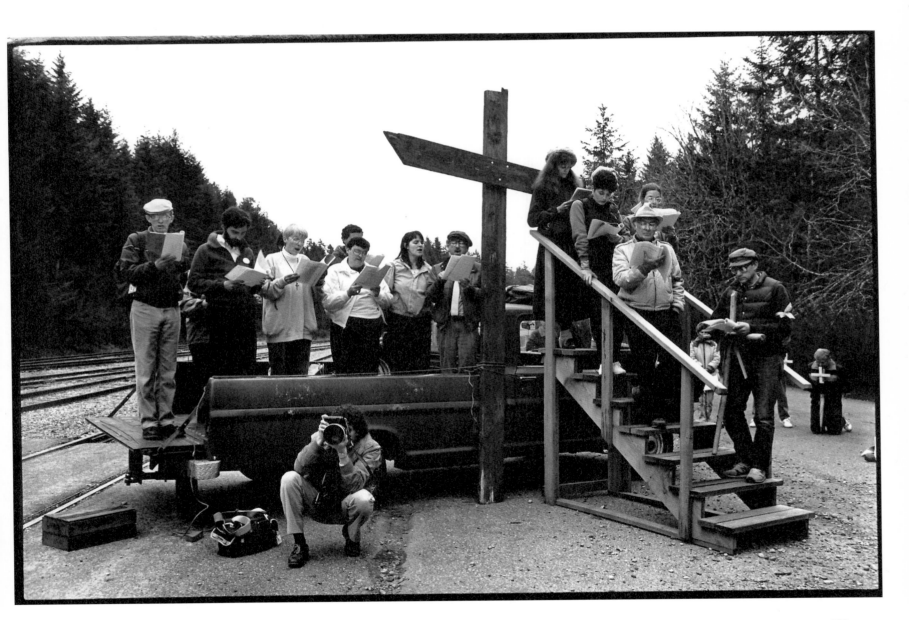

photograph, I moved away. Standing next to me, talking and milling around, were the people from the news media, including Mike Siegel from my own paper. I was used to the privileges of anonymity that went with my press pass. But this time I had been identified by the monitor as a marcher. I had come with a church group, marched with them, and stayed in the crowd when I photographed rather than position myself in front of the truck. I hadn't used special equipment such as a motordrive or a long lens, and I stood on the other side of the street while the organizers chained the cross to the gate.

I never saw anyone that I knew from the Christian Faith Center at any of the political events sponsored by the Seattle Church Council, and I never heard these events announced at the center. They had a very conservative agenda, and peace marches were not the kind of thing they went in for. They supported the status quo, they didn't fight it. I had privately thought of the Christian Faith Center as the upwardly mobile church. They had grooming classes for women and financial seminars for people who wanted instruction on how to get ahead in life. They emphasized financial success and the traditional idea of family and they defined material success as a reward for obeying the will of God.

I went to a child dedication ceremony at the Christian Faith Center in which parents carried their babies to the altar and held them while church elders laid hands on them (fig. 51). Afterward Casey Treat gave a sermon. He talked about children and how important it was to wipe rebellion out of their hearts. He said, "Rebellion is like the sin of witchcraft: it's a rebellion against society, against parents, and against the word of God. It's stubbornness, and you don't want to be stubborn, you want to be submissive. If you're willing and obedient, you'll eat the good of the land. When people ask me how come I drive that big Mercedes I tell them it's because I'm willing and obedient." The congregation applauded. He went on: "If you're disobedient, you're going to struggle and suffer." Next he told a story about a man who was willing and obedient. One morning this man said his prayers, as he usually did, and then boarded an airplane. The plane exploded. Casey Treat told how people were "cooked" to the left of the man and to the right of him, the row in front and the row in back, but, miraculously, the man survived. "Disobedience brings destruction in the presence of God. Judgment is immediate." This sermon implicitly outlined a chain of command: it's not just a matter of obeying

Fig. 50. Good Friday demonstration, U.S. Naval Base at Bangor

God but also of obeying all these other authorities and wiping out rebellion.

Faith Healing Some people at the Christian Faith Center told me about Frances and Charles Hunter, a couple who came to town once a year to do faith healing in the Seattle Center Coliseum (where I used to photograph the Seattle Sonics' basketball games). For three days before the big night of faith healing, the Hunters trained local Seattle people as healers and assistants. These people did most of the actual healing work in the Coliseum. The evening began with a mass prayer and sing-a-long, and then everyone was asked to leave the floor of the arena except the people with cancer, who were instructed to form a line down the length of the floor. The Hunters walked down the line, placing their hands on people's heads and shoulders, beseeching God to cure the cancer. When they finished, the rest of the crowd was invited down from the stands to the floor to form lines in front of the dozens of healers.

I photographed from the stage at one end of the coliseum during the opening prayer (fig. 52). Hundreds of people stood, arms raised, calling on God to help them. If you look at the photograph from far enough away, all those faces form a pattern. Because I was standing on the stage, the point of view of the photograph is downward, a perspective similar to that in the photograph of the phone crusade. What, I wondered, does such an event look like to the people running it, as they stand on the stage or at the altar and look down?

I made another photograph, while I was on the main floor, of a healer with her back to the camera and her hands pressed into the eye sockets of a blind man (fig. 53). "See no evil." To their left a young man waiting his turn covers his mouth with his hands. "Speak no evil." Sometimes, after the healer had finished with them, people would swoon and were helped to the floor in order to recover (fig. 54). In another healing line a young mother held a small boy who was mentally retarded and bent over double from a spinal deformity. As the healer put his hands on the boy and prayed over him, the boy made low, bleating sounds. Afterward, the mother, still holding her child, and the father stood side by side on the main floor. The mother was crying. A woman on stage sang religious lyrics to catchy pop and country tunes. Frequent appeals for money to do "God's work" came over the loudspeakers. The appeals always included a

Fig. 51. Child dedication, Christian Faith Center

Fig. 52. Faith healing, Seattle Center Coliseum

Fig. 53. Faith healing, Seattle Center Coliseum

story with this theme: you'd better give now, if you want to get.

Frances Hunter had told a story about a family — a mother, father, and two kids — down on their luck, with no home, no jobs, and hardly any money. The family gave its last ten dollars to the Hunters to show God how grateful they were to be alive, well, and together and that they knew there were people in worse straits. Frances said she had told the father and mother that they should keep the money, since they had so little. But the couple insisted she take it. The next day, while the family was having breakfast at a homeless shelter, the mother got a wire telling her that a patient at the nursing home where she used to work had died and left her one hundred thousand dollars. God, Francis explained, had rewarded their generosity. (She didn't explain how the telegram found the woman at a homeless shelter.)

Some people came to the faith healing in wheelchairs. Most were dressed in the clothes they might wear to church. One couple came with their five-year-old daughter. I first saw the child from the back, straight blond hair and a bright pink sweatshirt. Her father held her in his arms while they waited in one of the healing lines. She was clapping her hands over her head and moving her body to an upbeat country-western song about God. I kept watching because her movements were so delightful. Eventually she turned around to face me. I saw then that she had Down's Syndrome, and I knew why her parents were standing in the healing line.

I started for the exit. I'd had enough. I was angry at the parents for being so foolish as to think the Hunters could heal their child. I was angry at the Hunters because what they were doing was such a gross exploitation of these people's situation. I made my way through the crowd and was halfway to the door when one of the young men responsible for guarding the stage area approached me and said he'd been wanting to talk to me all evening. He asked me my name, and I told him. He'd been watching me, he said, and could tell I was Christian. "You're wrong," I said, "I'm Jewish" (although I'm not). I thought that would get rid of him, but he only came back with some story about the Jew being the olive and the Christian being the root, or vice-versa. I stood there and stared at him. He was hitting on me. Unbelievable. "Well," I said, "I have to go now." And he said, "Shalom, Dianne."

Ben Benschneider of the *Seattle Times* photographed the same event for the newspaper. While I was on the stage making my panoramic view

Fig. 54. Faith healing, Seattle Center Coliseum

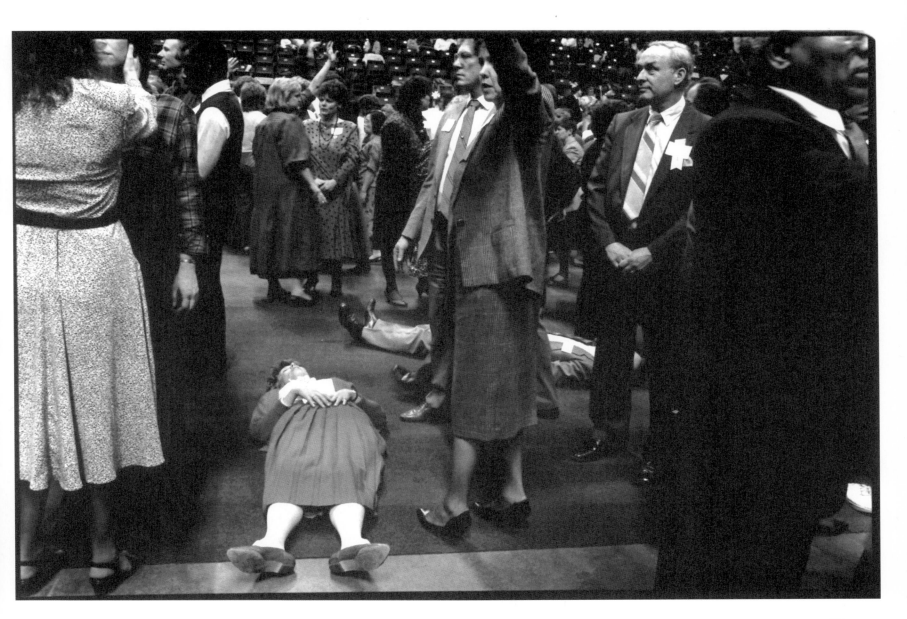

of the crowd I saw him down on the floor photographing "tight." I wondered what the hell he was doing down there. The "picture" was from up here on the stage. He might well have wondered what I was doing on the stage. There were good reasons why we were standing in different places, making different photographs: our organizational commitments were different, we were making our photographs for different purposes, and our aesthetics were different.

Ben was making his picture for a newspaper. Newspaper work is routinized. Reporters write standard stories about standard topics and photographers photograph them in standard ways. He was doing this assignment because it occurred during his work shift, and he was making the photograph that would fit the paper's requirements. His assignment sheet had told him what the story was before he left the newspaper office. He was there to make the best picture he could, given the limited possibilities his job made available to him. I was photographing the event for quite different reasons, and any photographs I made would appear with many others about related topics and with a different text in a different vehicle: a book. If I decided not to print or use any of the photographs I made at this particular event no one would care. I had no one to answer to. No editor was waiting for me to come back to the newsroom with a picture illustrating this story. I had created my own story through the long, evolving process I describe in this book.

Ben's photograph appeared in the next day's newspaper (fig. 55). It had been cropped to run along the entire width of the top of a page in the front section. The photograph shows the sharply focused face of a woman at the bottom center of the frame. Her head is tilted upward and catches the light shining from above, her eyes are closed, her mouth is open, and both of her arms are raised. Behind her and to one side are the faces of two other women, out of focus, also with their arms raised, and with similar, although less dramatic, facial expressions. Other raised palms are visible near the left and right edges of the frame. Beneath the photograph was the headline: "'Explosion' crowd of 6,000 with 1,100 trained healers." Beneath the headline was about twenty inches of text about the Hunters and their "so-called 'explosions' to heal masses of people."

A different aesthetic is operating in the two photographs. A good photograph for Ben would not have been a good one for me, and vice versa. The formal devices he used suited the purpose of his photograph.

Fig. 55. Photograph made by Benjamin Benschneider for the *Seattle Times*.

He used selective focus to create a center of attention on the face of an individual with an exaggerated, emotional expression, thus personalizing the event and producing a dramatic image that would be hard for readers to ignore as they turned the pages of the Saturday morning paper. The devices I used were suited to the purpose of my photograph. I used a wide depth of field and a wide-angle view to emphasize the large number of people and the pattern of their collective activity. I made sure to include the ceiling banners announcing the various championships the Seattle basketball team had won because they indicated that this event was held in a secular space, an idea integral to my conception of the project.

"Easy" Targets I graduated from the University of Washington with a Master of Fine Arts in the spring of 1987, having finished what became the first half of this project. During my final meeting with my graduate committee, Chris Cristofides, a professor of art history and one of my committee members, told me that my photographs didn't make an easy target of religion in the way someone might have with TV evangelists, for example. I've thought about that since then. What would it mean to make religion an "easy target"? The fund-raising frauds and sex scandals involving clergy make it easy to portray these evangelists as hypocrites. But it's less easy to do that with a church group that gives shelter to Salvadoran political refugees. I had made an easy target of religion in the "holy aura" picture of the pastor from Burien (fig. 12), in the sense that the form and the concepts were already cultural stereotypes, well-known ways of representing well-known sentiments, clichés really, buttons that, when pushed, automatically trigger a whole string of ideas.

I think targets are "hard," in contrast, when both the forms of expression and the concepts you use recognize contingency, complexity, even contradiction. It's a way of looking: the scope is broad, the concept complicated rather than simplistic. Systems are harder targets than personalities. I can sometimes say without reservation that someone (Jim Bakker, for instance) is not my idea of a good person. But I cannot condemn some people and their motives — the church groups supporting Salvadoran refugees — so unequivocally. There are things about many of these activities or people that embody or perpetuate a sexist and

hierarchical world view I do condemn. But they aren't simply hypocrites. That makes for a hard target. My notion of religion came to include both the Jimmy Swaggarts of the world, who I do not respect, and the Dianne Quasts, who I do. To represent these complexities in photographs that demand reflection and a critical response makes the target hard.

These difficulties become more apparent when you start thinking about fixing things, changing the world. When your view of the world accepts that everything is infinitely interconnected, you can't just point at one thing and alter it. The world won't be all better once a few corrupt preachers go to jail. I realized that my work wasn't going to solve any problems, but rather would identify connections and make evaluations. The evaluations get more complex when the scope of the connections is broader. The criticisms of religion in this project are not localized in the missions or with the TV evangelists because those organizations and people are only parts of a larger system of religious activity, all of it implicated in hierarchy and sexism. So a hard target is a complicated target, one not reducible to simple judgments of good or bad.

Once I no longer confined my work to the missions or the churches directly linked to them, I was working with organized religion in the larger community, exploring its connections and intersections with the secular world, both public and private. That made it increasingly difficult to sustain a simple view of religion, one that would let me make an easy target of it. I wanted to understand how religion connected with the secular world, how, for instance, it shared physical space or got into secular parts of the mind. Religion has a far-reaching influence on everyone's life, whether they attend church or not, watch Oral Roberts or consider themselves atheists. Religion helps sustain ideas in other arenas of social life. Easy target/hard target is a choice you make about how to describe something, a choice about how broad an area to incorporate conceptually, a choice about what kind of story to tell.

What Am I Looking At?

"I intended the photographs to embody the analysis"

The photograph of the wedding at Central Lutheran (fig. 44) was made for my own analytic purpose, to explore some culturally held notions about women. In this way, any meanings — about weddings and churches or brides and their dresses — that this particular photograph might have for me or for others became independent of the specific feelings, thoughts, and ideas the bride in the photograph may have had while I was photographing. This is true of every photograph in the book.

A process of separation and recombination occurs in every medium of recording or representation. This photograph is three-dimensional space translated onto a two-dimensional strip of film, the colors and brightness translated into shades of gray, 1/30th of a second yanked from a continuing, unfolding ritual. The simultaneity of that instant and its original context — all its detail and complexity, including the multiple inner voices of the bride and the other people in the image — disappear and cannot be recovered. One can only guess at what came before and after that instant. Instead there is a new before and after — all the words and images preceding the photograph's appearance in this book, and all the words and images following it.

The meaning of this wedding photograph cannot be given in a single sentence; rather, it arises in a web of ideas and associations developed in the context of both the photograph's use and its reception by a viewer. I made the photograph of the bride intending to combine it with text and other photographs made at different times and places that together would embody an analysis of aspects of religion. I did not intend it to provide ethnographic data about a particular wedding. Thus, it elides the particular situation and history of the bride — Is she young or middle-aged? Is this her first or some subsequent marriage? What is her social class? — although cues in the photograph suggest answers to some of these questions.

The significance of this particular wedding for me was not what was

most significant or meaningful for the bride or anyone else in the photograph. I can guess at what might have been in her mind at that moment, based on my experience of weddings and of the world, but I can't know for certain. I could have asked her what she was thinking about, but I wouldn't know if what she said was an accurate account of what was in her mind or one tailored to what she thought I wanted to hear. Besides, we don't think only in words, only in images, only consciously. To communicate her thoughts, the bride would have had to translate them into words.

In any case, the event's significance for her was not relevant for my purpose. It is not a photograph designed to "reveal" that kind of "reality." Rather, the emphasis I gave the woman standing at the church door in her white wedding gown resulted from the place I had started and the subsequent path my research had taken. My perspective on this particular wedding, the significance I saw in it, the associations I made to it, evolved during my progress down that path, as had the way I made the photograph: where I stood, how I composed it, what I included in the frame, what lens I used (this was a decision about angle of view and the relative distance between and relative size of objects in the foreground and background), what was sharply focused and what was not, how I exposed and developed the film (which, among other things, affects the detail visible in the shadow and highlight areas and thus how white the dress looked).

Finding the Vocabulary

One reason for outlining the development of this project was to use it as a specific example of how work is shaped by the process of doing it, the process of discovering what the result will be, the process as an ongoing analysis. When I began the project, I was working with methods and models derived from and suited to the requirements of the newspaper business. But, as the work evolved, what I wanted the photographs to be about and accomplish left those requirements behind. As I developed new conceptual and visual tools, they, in turn, opened up new questions and new forms of visual expression. As a consequence I found myself reconceptualizing how I used multiple photographs — images that, taken together, explore an idea with greater subtlety and nuance than could any individual photograph alone. I eventually began making photographs that

contained many references to ideas contained in other photographs — qualifications, expansions, and elaborations of those ideas — and single photographs could no longer communicate my full meaning. This way of working with photographs uses the novel, rather than the oil painting, as its model. The individual image is not the conceptual unit. The conceptual unit is the combination of many images.[20]

Making links between photographs became an automatic part of my working method. Having developed a group of related ideas, I was always alert for particular objects I could photograph that might express those ideas symbolically. As I photographed, I fleshed out ideas and tried to expand their meanings by describing them in a new context. When I saw people in different settings who were dressed alike or doing something in the same way, the similarity of their dress or action suggested to me that a common idea might underlie the surface similarity. Sometimes I found that objects I initially included in the frame, because they suggested the shape of something else in that frame or in another photograph, had a conceptual connection to other photographs. I learned to be sensitive to these connections, even before they were fully developed in my own mind, even though I had only a vague intuition that there might be specific connections and references. The pattern of passive postures, for example, became apparent to me only when I compared the photographs of religious services, Sunday schools, and other activities in the churches and the missions, and especially when I compared the postures in those photographs to the less submissive postures people displayed in the posed portraits I made in their homes. Once aware of the pattern, I made a photograph whenever I saw a variation, as had happened when I photographed two women leaving Our Lady of Fatima Church after the pope's video mass (fig. 56). Although they were not part of a group engaged in some religious activity, their stooped postures combined with the figure of Jesus looming over them to suggest a more general version of the theme of passivity.

Another broad notion that I worked with — technology and religion — began as a vaguely intuited connection between video popes and TV evangelists. But I didn't see any specific connection between telephone poles and evangelism in the photograph of the cross raising at the Korean Christian Church (fig. 32) until after I photographed the Billy Graham telephone crusade (fig. 40). At the time, I included the poles because they were a unifying compositional device, they looked like crosses, and they

Fig. 56 Our Lady of Fatima Church

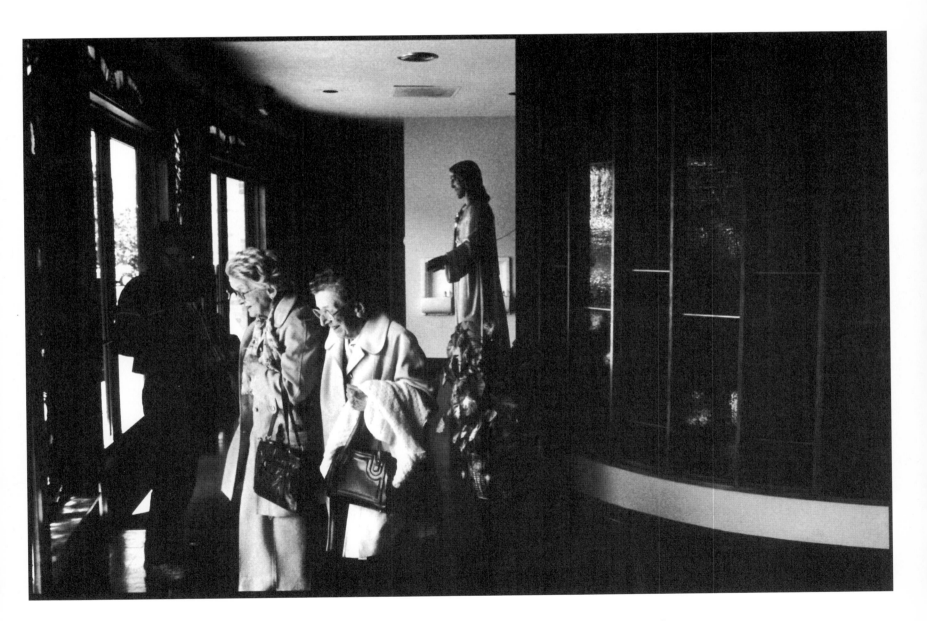

Fig. 57. St. John Catholic Church

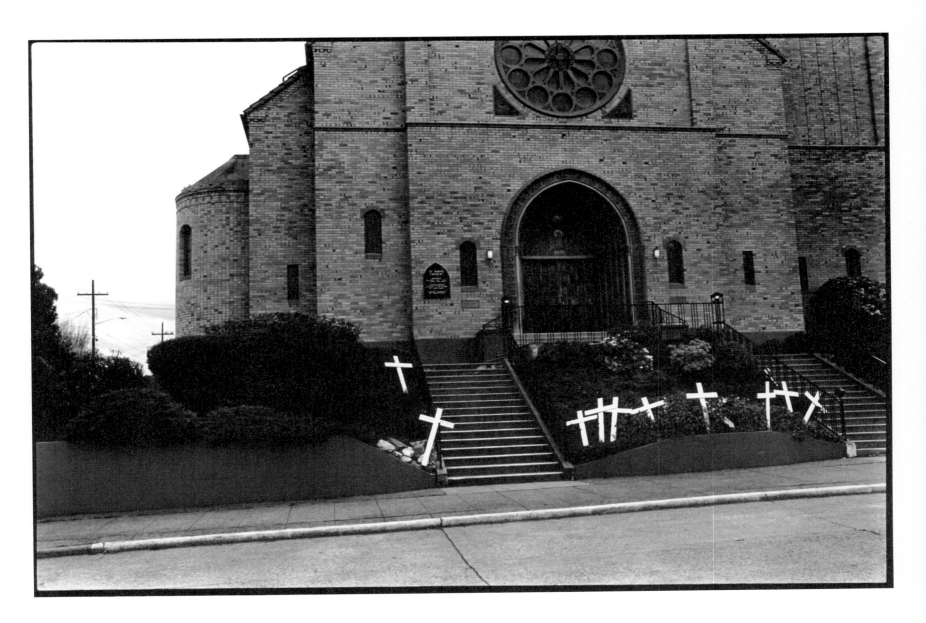

alluded, in some vague way, to the church's environment: the neighborhood and city in which it was located and the more general communicative process that makes up urban life. I could have explained the presence of the poles in the frame, had anyone challenged me, by saying that it was difficult to avoid including them. But that would be disingenuous: I could have kept them out, had I wanted to, by moving closer to the church. If I still wanted the sense of the neighborhood, as I did, I could have tilted the camera downward and excluded the tops of the poles (and with them the reference to crosses) or shifted it to the left to eliminate one pole and downward to eliminate the top of the other. I could have walked higher up the hill, so that the poles would not stand out in relief against the sky (which called attention to them) but rather would blend into a dark background (although then the cross would as well).

After I photographed the Billy Graham telephone crusade, however, I began deliberately including telephone poles in other photographs. Besides their physical similarity to the cross, I realized that they were an integral part of a communication technology, which suggested to me the complexities of evangelism and the telephone's function as a specific means to spread the faith. By using the poles as another motif and widening their context, I wanted to transform the physical similarity of the crosses and telephone poles into a conceptual similarity viewers would recognize, so that eventually the poles would *become* crosses and carry all the meanings crosses had acquired in the course of the project. For example, in the photograph of St. John Church (fig. 57) I made sure that the poles were visible beyond the white crosses that had been placed in front of the church at the end of a march by politically liberal congregations to protest the assassination of Oscar Romero, the left-wing Central American archbishop. A photograph of the march (fig. 58), also displays the poles prominently.

Every project has its own characteristics. Every researcher comes with a different set of theories and skills. As a result, we go to different places, perhaps make different connections. There are many possible choices at every point. I did not pursue points of departure that might have been profitable in other ways, that others might have chosen: the ins and outs of the social welfare system that the homeless have to deal with is an obvious example. The appropriate methods and vocabulary of forms for a project depend on choices of that kind.

The particular way I made the photographs in this project is not a

Fig. 58. Eighth annual Archbishop Oscar Romero Procession

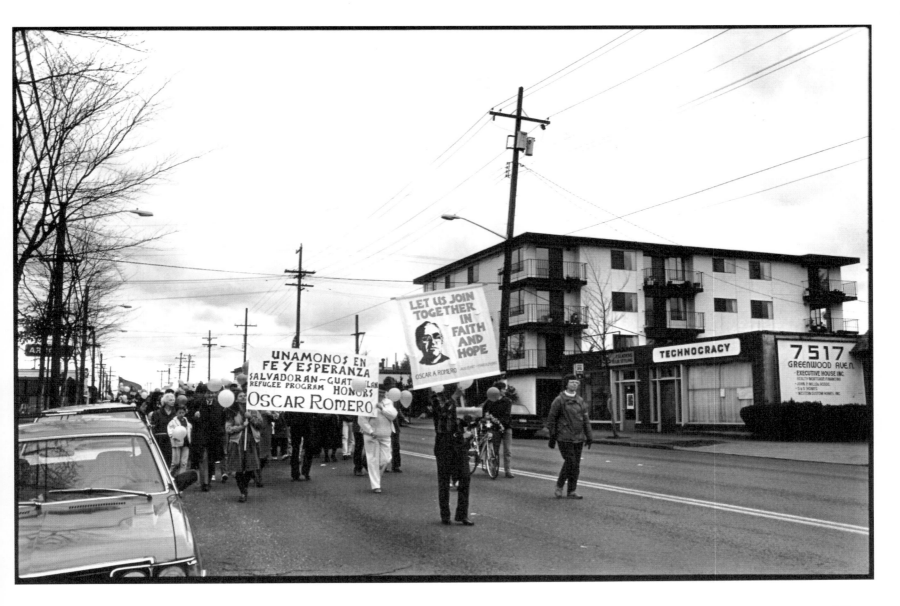

recipe I can transfer "as is" to any other project. This is not a "how to" book, not a new set of recipes for creating successful documentary photographs and projects, designed to take the place of some older, outmoded set. In that sense, there is no one right way to proceed. The right way varies from project to project, person to person, subject to subject, and is discovered in the process of doing the work. Part of the job is to invent the appropriate vocabulary and concepts for what you're studying: the symbolic vocabulary, the evolution of the ideas. The form and the content, the visual structure and the ideas, are also tied to the situation in which the work is done.

The difficulty and frustration of not finding an existing, appropriate vocabulary to express emerging concepts, and of having to find or invent a new one, is a theme many others have explored. T.S. Eliot discusses the problem explicitly in *Four Quartets* (East Coker, V):

> Because one has only learnt to get the better of words
> For the thing one no longer has to say, or the way in which
> One is no longer disposed to say it. And so each venture
> Is a new beginning[21]

Every documentary photographic project requires its own strategy, a way of gathering, combining, and presenting materials that will enable the expression of ideas that cannot otherwise be got at (or can only be got at with great difficulty and compromise) in conventional forms. Conventionally available forms work most insidiously when they operate in our own heads as internalized rules, as the rules of newspaper photojournalism had operated in mine to define appropriate subject matter, good photographs, what a story is, what visual means. Changing these internal boundaries is difficult.

Form and content are inseparable. They are each other's contingency. We discover new content, new ideas, by discovering a new way to say something, just as I learned to step back, put more than one center of interest in the frame, and so create a visual statement of relationship. The methods of making photographs and the formal devices used are best left flexible. We have to alter their shape, so as to alter their content, when our inquiry takes us in a new direction, when we reformulate the questions we ask about what we're looking at.

Fig. 59. St. James Cathedral

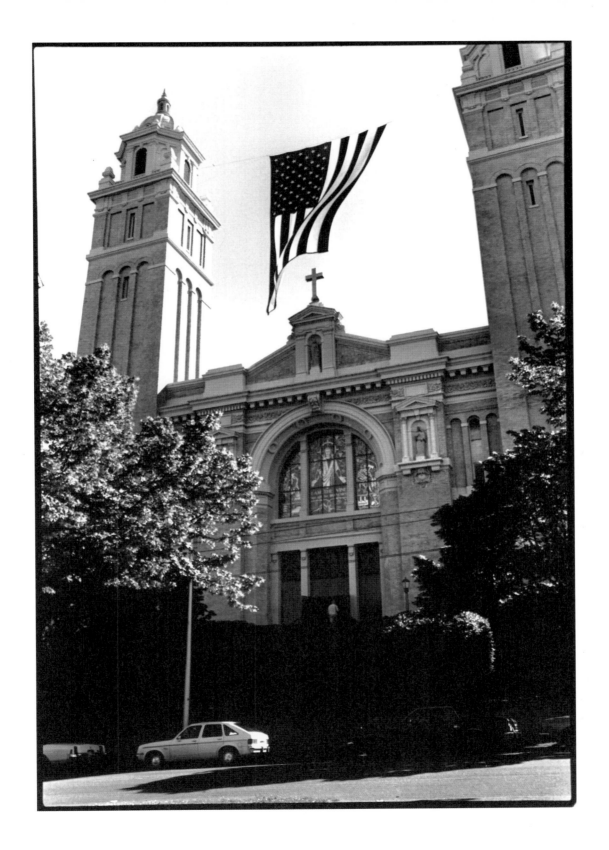

Notes

1. John Long attributes this phrase to Rich Clarkson in "Knowledge: Key to Power in the Newsroom," *News Photographer* 45 (May 1991): 13.

2. Everett C. Hughes, "Studying the Nurse's Work" and "Psychology: Science and/or Profession," *Sociological Eye* (New Brunswick, N.J.: Transaction, 1984), 311-15, 360-63.

3. Gerald D. Hurley and Angus McDougall, *Visual Impact in Print* (Chicago: Visual Impact, 1976).

4. Long, "Knowledge," 12-13.

5. Karin E. Becker, "Forming a Profession: Ethical Implications of Photojournalistic Practice on German Picture Magazines, 1926-1933," *Studies in Visual Communication* 11 (Spring 1985): 45-60.

6. *The Concerned Photographer*, ed. Cornell Capa (New York: Grossman, 1968).

7. The conventions of visual imagery that I learned as a journalist are described in Gaye Tuchman, *Making News: A Study in the Construction of Reality* (New York: Free Press, 1978); Herbert J. Gans, *Deciding What's News* (New York: Vintage, 1980); and Harvey Molotch and Marilyn Lester, "News as Purposive Behavior: On the Strategic Use of Routine Events, Accidents, and Scandals," *American Sociological Review* 39 (1974): 101-12. I have discussed the conventions specific to one genre of news photograph in "The Joy of Victory, the Agony of Defeat: Stereotypes in Newspaper Sports Feature Photographs," *Visual Sociology* 8 (Fall 1993): 48-66. The arguments made there apply to photojournalistic practice generally.

8. David Sudnow describes similarly embodied learning in his *Ways of the Hand* (Cambridge: Harvard Univ. Press, 1978), which deals with the way he learned to play jazz piano.

9. James R. Milam and Katherine Ketcham, *Under the Influence: A Guide to the Myths and Realities of Alcoholism* (Seattle: Madrona, 1981).

10. Had I known, I could have found much information on these topics in Jacqueline Wiseman's *Stations of the Lost* (New York: Free Press, 1979) and James Spradley's *You Owe Yourself a Drunk: An Ethnography of Urban Nomads* (Boston: Little Brown, 1970).

11. The term *pushing film* refers to a technique used in low-light conditions. The film is exposed at a speed rating higher than its recommended rating. The film is then given a special development to compensate for the resulting underexposure. Pushed negatives are usually more contrasty (less shadow and highlight detail) and more grainy than negatives processed normally.

12. A smaller aperture lets less light reach the film, so to get the same result you have to let the light in for a longer time by keeping the shutter open longer.

13. John Collier Jr. and Malcolm Collier discuss these points in chapters on "Mapping" and "Cultural Inventory" in *Visual Anthropology* (Albuquerque: Univ. of New Mexico Press, 1986).

14. Keith Smith gives a wonderful explanation of this layered complexity of visual images by comparing it to musical composition in *Structure of the Visual Book* (Rochester: Visual Studies Workshop Press, 1984), 41-64.

15. See the discussion in Howard S. Becker, *Art Worlds* (Berkeley: Univ. of California Press, 1982), 1-39.

16. See Jay Ruby, "Post-Mortem Portraiture in America," *History of Photogaphy* 5 (July-September, 1984): 201-22, for a discussion of an earlier tradition of using post-mortem photographs for these purposes.

17. Thomas S. Kuhn, *The Structure of Scientific Revolutions* (Chicago: Univ. of Chicago Press, 1970), 35-42.

18. I was reminded by this scene of Kristen Luker's account of how home computers for mass mailings and call forwarding enabled women to operate an effective anti-abortion public relations campaign from their homes. See her *Abortion and the Politics of Motherhood* (Berkeley: Univ. of California Press, 1984), 219-22.

19. Barbara Norfleet has assembled photographs of wedding dresses and wedding ceremonies in *Wedding* (New York: Simon and Schuster, 1979).

20. I specifically have in mind here Walker Evans's *American Photographs* (New York: Museum of Modern Art, 1988); Robert Frank's *The Americans* (New York: Grossman, 1958); and Nathan Lyons's *Notations in Passing* (Cambridge: MIT Press, 1974).

21. Excerpt from "East Coker" in *Four Quartets*, copyright © 1943 by T.S. Eliot and renewed 1971 by Valerie Eliot, reprinted by permission of Harcourt Brace & Company.